ROCKIES MARINERS
A's YANKEES
B S RED TWINS
RED
SOX
ROYALS RANGERS PADRES MARLINS
BACKS
DIANS JAYS

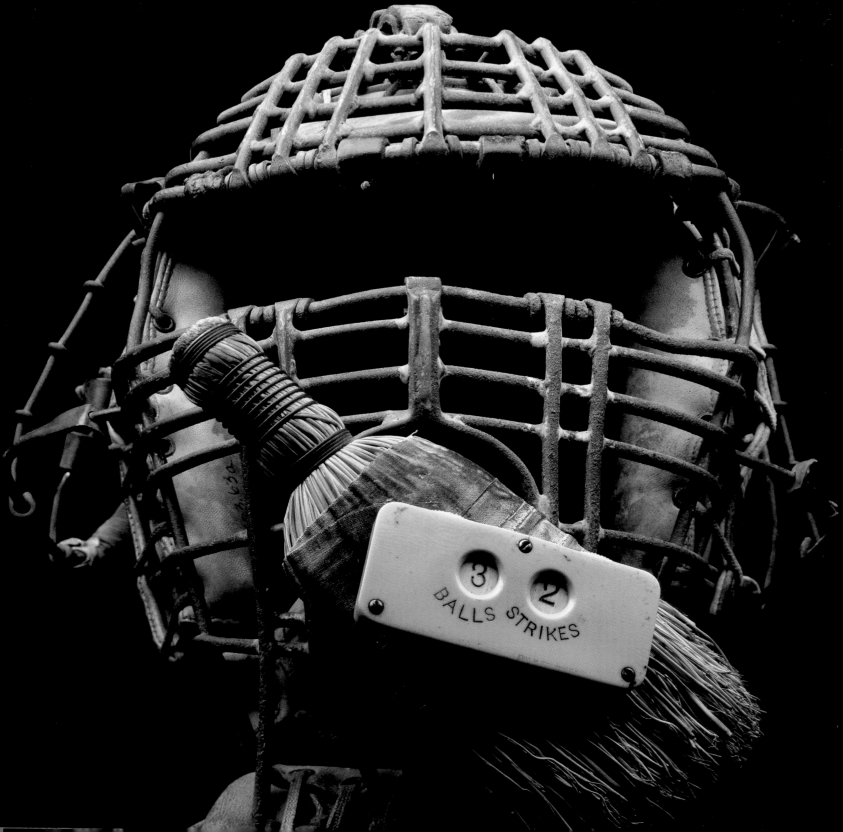

100 BASEBALL ICONS

FROM THE NATIONAL BASEBALL HALL OF FAME AND MUSEUM ARCHIVE

PHOTOGRAPHY BY TERRY HEFFERNAN

DESIGN BY KIT HINRICHS

TEXT BY DELPHINE HIRASUNA

TEN SPEED PRESS

Berkeley | Toronto

Major league baseball is a culture unto itself, steeped in its own traditions and lore. The rules of the game have remained virtually unchanged since the late nineteenth century. **N**ine players, three strikes, three outs. The bases are ninety feet apart, the baseballs made of leather and twine, and the bats constructed of wood. This constancy readily invites comparisons of box scores, averages, and on-base percentages of players and teams, predecessors and peers. It has turned the analysis of baseball statistics into a pastime of its own, encouraging animated debates among fans on individual player and team performances and who ranks as the greatest baseball player in the history of the sport.

Ted Williams's .344 lifetime average. Cy Young's perfect game in 1904. Lou Brock's 938 lifetime stolen bases. This is the stuff of legends. **D**ecades later the stats bear witness to these amazing feats and set benchmarks for each new generation of players. The balls, bats, uniforms, and even the cleats of major league immortals such as Babe Ruth, Willie Mays, Mickey Mantle, and Hank Aaron continue to evoke reverence and awe, stirring rich memories of glories past. **I**n *100 Baseball Icons*, we mine the treasures of the world's most famous repository of baseball memorabilia, the National Baseball Hall of Fame and Museum in Cooperstown, New York, to present a panoply of baseball over the last century.

BASE

THE GREAT

PASTIME 18

BALL

AMERICAN

39 ᵀᴼ TODAY

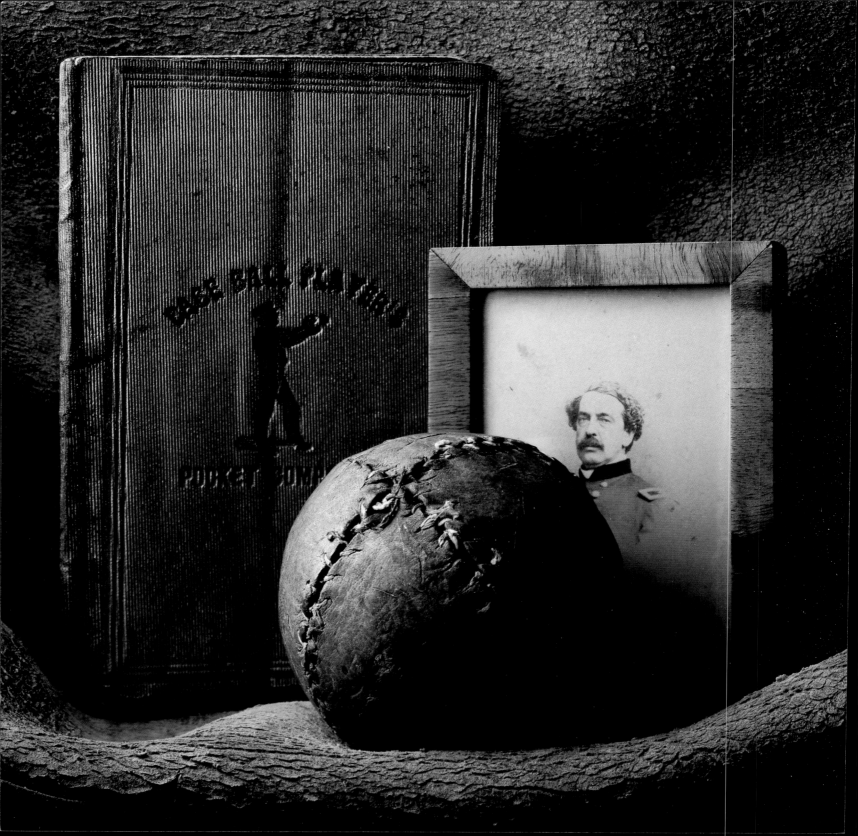

**Start of
Modern Baseball**

Abner Doubleday,
later a Civil War
general, is said to have
invented baseball in
1839 when he marked
a diamond-shaped field
in the dirt and added
bases, a pitcher, and
a catcher. Although a
commission concluded
in December 1907
that Doubleday came
up with the game in
Cooperstown, New
York, no evidence
exists to support that.
In fact, it is known that
Doubleday was not in
Cooperstown in 1839.

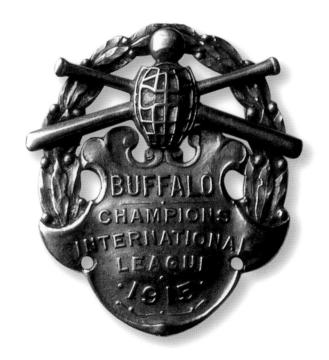

**International
League Medallion**

A Triple A minor
league that operated
in the eastern United
States, the International
League traces its start
to 1884. In 1915 and
1916, the Buffalo
Bisons grabbed the
league championship,
then did not win another
pennant until 1927.

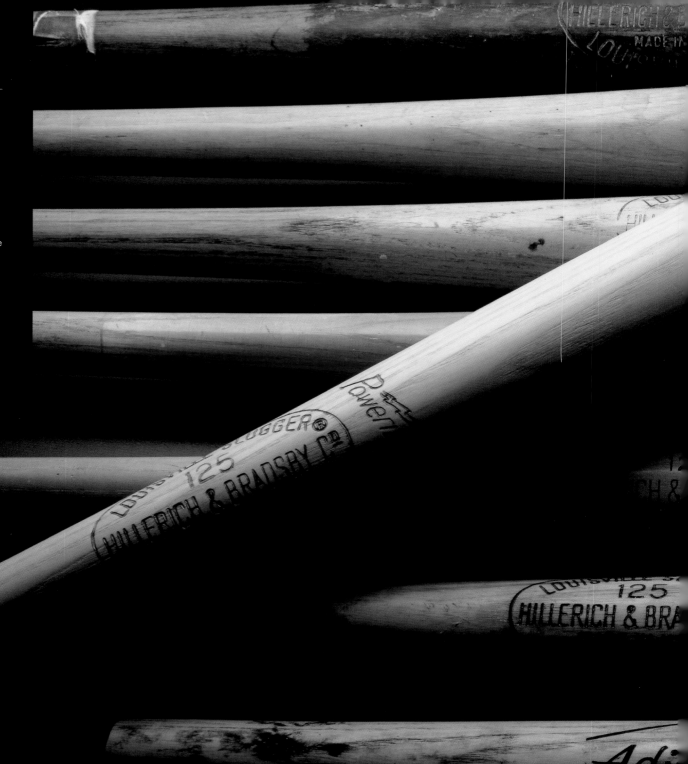

Legendary Bats

The bat and ball used by Hank Aaron to hit his record-tying 714th home run lie atop a row of other legendary bats, including the one used by Bobby Thomson to launch "the Shot Heard Round the World" in the Giants' 1951 pennant play-off with the Dodgers.

2	Zum	C	Capra
3	Evans	B	Easterly
		C	Asper
4	Aaron	B	Office House
		C	Frisella
5	Baker	B	
		C	Tepedino
6	Johnson	B	Foster Miller
		C	Oates
7	Correll	B	Office
		C	Perez
8	Robinson	B	Tepedino Foster
		C	Perez Casanova
9	Reed	B	Oates Murrell
		C	Capra
		D	

Hank Aaron's
715ᵗʰ Home Run

Mathews

MANAGER'S SIGNATURE

**Historic Game
Roster**

Hank Aaron of the
Atlanta Braves entered
the 1974 season just
one home run shy of
Babe Ruth's record. On
April 8, 1974, he made
history by hitting his
715th homer — a feat
noted at the bottom
of the line-up roster
for the game.

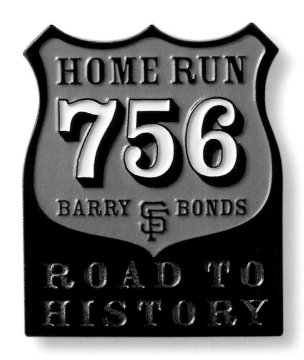

New Record Pin

San Francisco Giants'
slugger Barry Bonds
became the new home
run king on August 7,
2007, when he hit his
756th homer, sending
the ball 435 feet. Fans
at the game were given
a pin commemorating
the milestone event.

13

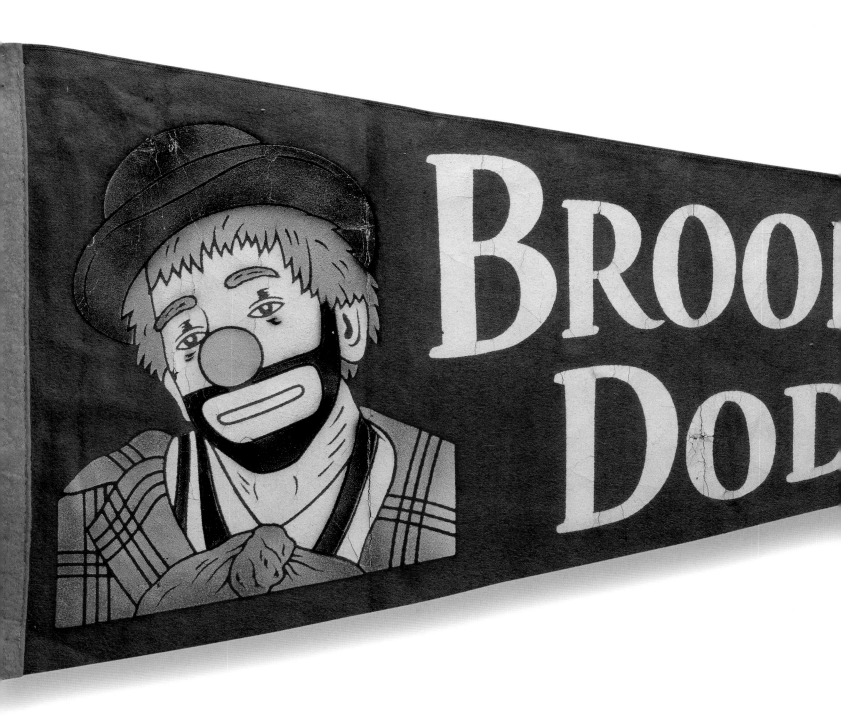

14

Clown Kelly Pennant

Legendary clown Emmett Kelly
took the 1957 circus season
off to perform as the Brooklyn
Dodgers mascot. His "Weary
Willie" character appears on
the team's last banner.

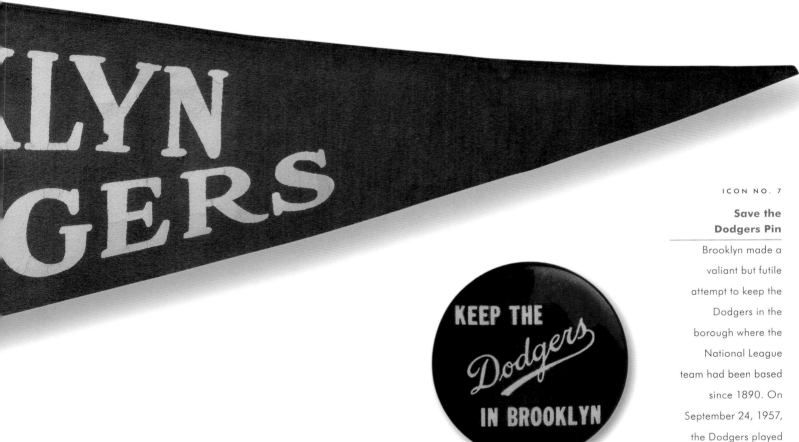

**Save the
Dodgers Pin**

Brooklyn made a
valiant but futile
attempt to keep the
Dodgers in the
borough where the
National League
team had been based
since 1890. On
September 24, 1957,
the Dodgers played
their last game at
Ebbets Field before
moving to Los Angeles.
Brooklynites were
heartbroken.

Press Pins

Since 1911, the members of the media have been issued lapel pins giving them access to the press box at World Series games. The custom was picked up for the All-Star game in 1938 as well. Today reporters are issued laminated paper passes, and the pins are treated as commemorative giveaways. Because the pins are never sold to the public, the early ones have become very collectible. The pin of the winning team typically commands a higher price than that of the losing team.

1902 Season Pass

When it opened in 1902, the Cincinnati Ball Park, dubbed the "Palace of the Fans," issued sterling silver season passes to Cincinnati Reds' games, engraved with the holder's name. The 6,000-seat ballpark was the second major league stadium to be made of concrete and iron. The Reds stopped playing there in 1911.

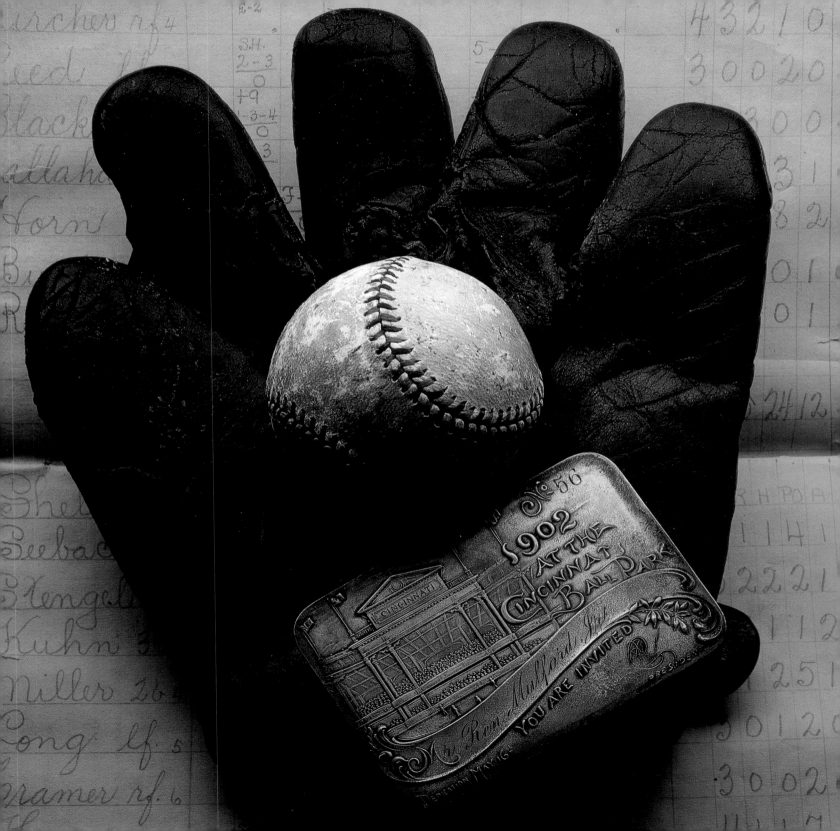

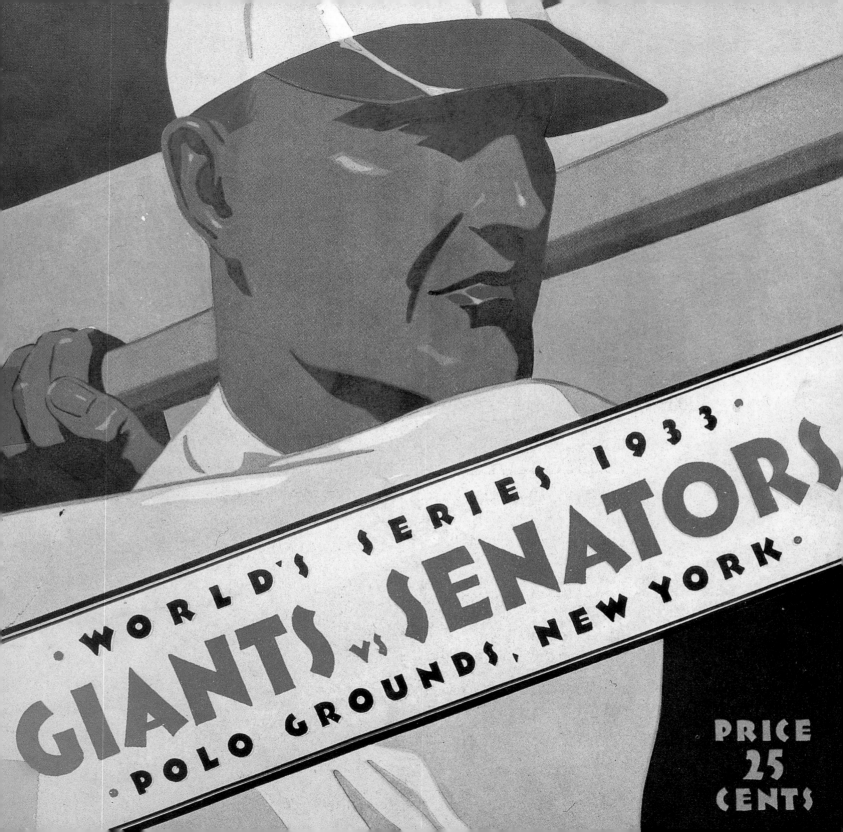

WORLD'S SERIES 1933

GIANTS vs SENATORS

POLO GROUNDS, NEW YORK

PRICE 25 CENTS

**1933 World
Series Program**

The 1933 World
Series pitted the New
York Giants against
the Washington
Senators, with the
Giants winning in
five games for their
first championship
since 1922, and their
fourth overall.

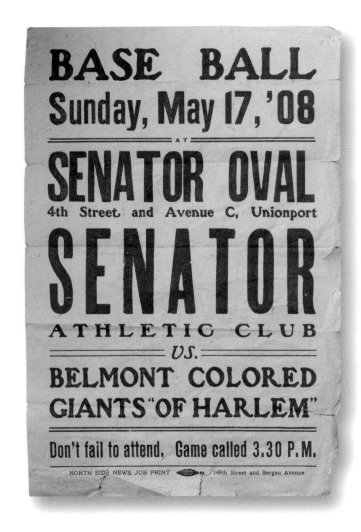

**Negro League
Broadside**

Until Jackie Robinson
broke the major
league color barrier
in 1947, African
American players
were segregated into
their own professional
leagues, the earliest
of which was formed
around 1887. At the
start of the twentieth
century, some two
hundred independent
all-black teams existed
around the country.

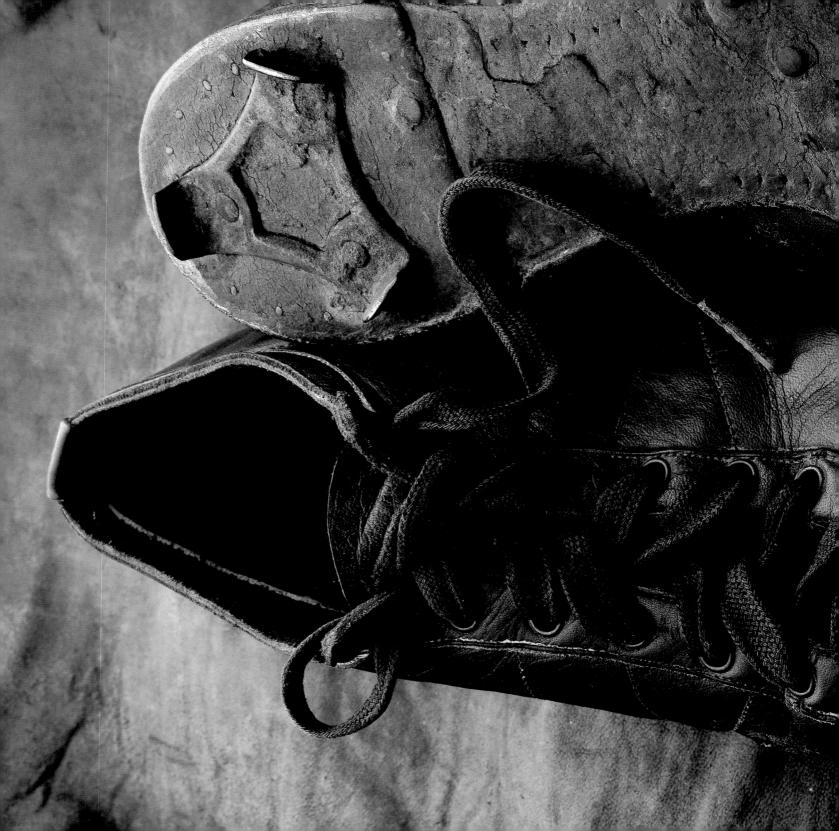

Joe Jackson's Shoes

One of eight Chicago White Sox players accused of throwing the 1919 World Series, Joe Jackson was acquitted in the notorious "Black Sox" trials, but was still banned from the major leagues. He got the name "Shoeless Joe" when he once played in his stocking feet because a new pair of shoes gave him blisters. These are his shoes from the fateful 1919 season.

**War Bond
Game Tickets**

During World War II,
about 90 percent of the
major league players,
including thirty-five
Hall of Famers, served
in the U.S. military.
The major leagues
also supported the war
effort by holding games
to encourage the sale
of war bonds.

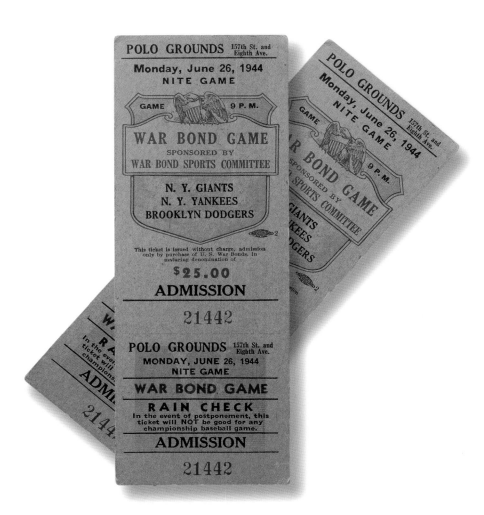

ICON NO. 16

**Polo Grounds
Memorabilia**

Polo Grounds is the
name given to four
different stadiums in
Manhattan. The New
York Giants played
at the Polo Grounds
from 1891 to 1957.
The field was also
briefly the home of the
New York Mets, until
Shea Stadium was
completed in 1964.
Along with tickets
and the 1911 opening
day ball, the Hall
of Fame collection
includes a megaphone,
bleacher aisle letters,
and a first base bag.

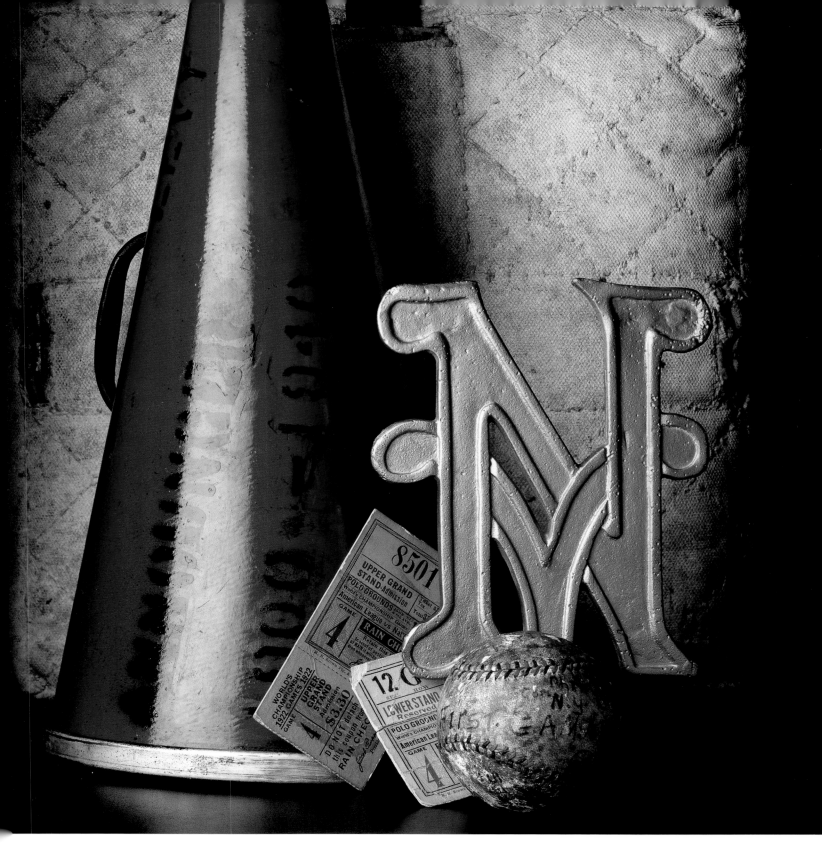

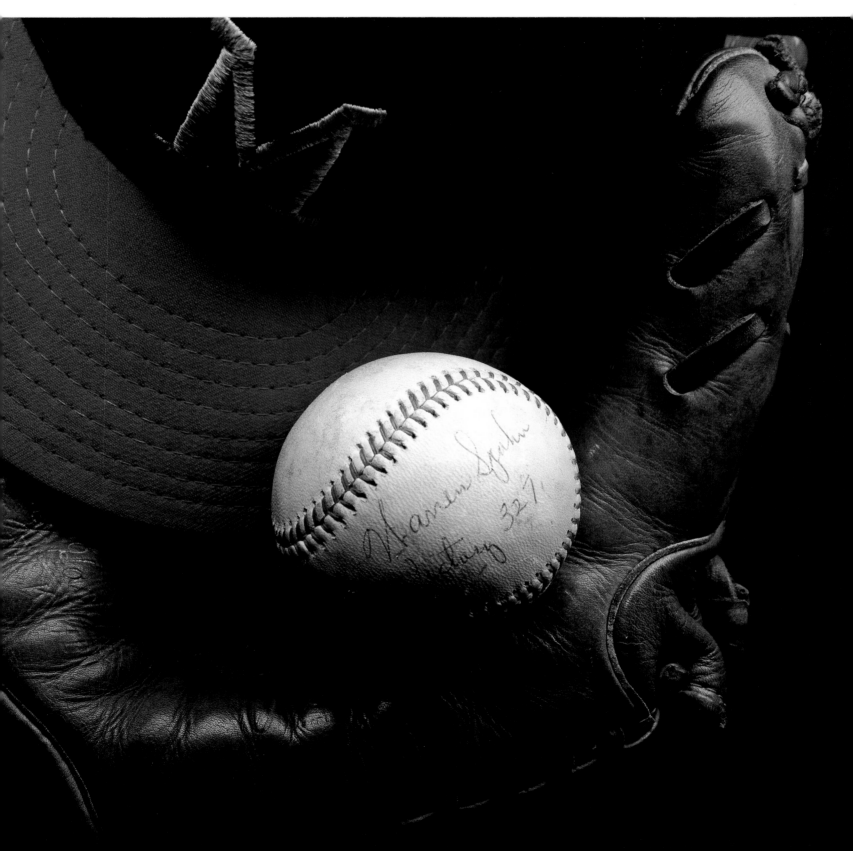

**Warren Spahn's
Gear**

Warren Spahn is often
lauded as one of the
best southpaw pitchers
ever. For thirteen sea-
sons he won twenty or
more games. Here, his
Milwaukee Braves cap
is shown with the ball
from his 327th victory
and the glove from his
267th win, which broke
the previous National
League record for
left-handers.

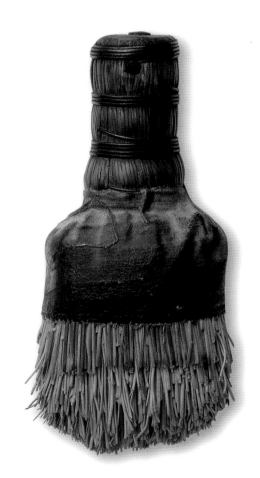

Umpire's Broom

Until 1904, major
league umpires swept
the dirt off home plate
with a long-handled
broom, which they
then tossed to the side.
But after a Chicago
Cub named Jack
McCarthy tripped on
the broom while racing
for home and seri-
ously injured his ankle,
the National League
ordered its umpires
to use short whisk
brooms that could be
stowed in their hip
pockets. A year later
the American League
adopted the same rule.

Rookie of the Year Pin

In 1947, Jackie Robinson not only broke the color barrier when he became the first African American to play in the major leagues, he also was named "Rookie of the Year." Two years later he won his first MVP award. During his ten years on the team, the Dodgers went to six World Series.

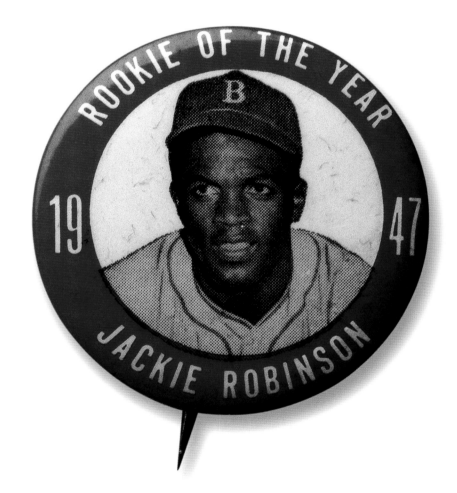

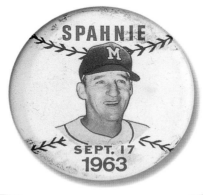

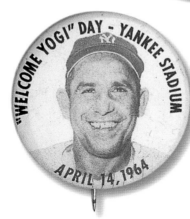

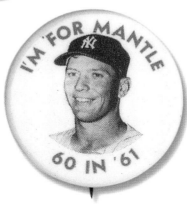

Promotional Pins

Over the years, pins
were issued to honor
specific players. The
September 17, 1963,
Milwaukee Braves game
at County Stadium was
declared a tribute to
Warren Spahn; Presi-
dent John F. Kennedy
called in to congratulate
Spahn. A 1964 pin
welcomed Yogi Berra as
the new manager of
the New York Yankees.
In 1961, fans rooting
for Mickey Mantle in
the friendly duel with
Roger Maris to break
Babe Ruth's season
homer record sported
"I'm for Mantle" pins.

1924 World Series Ticket

In 1924, the New York Giants competed in their eighth World Series in fourteen years, this time against the Washington Senators. The Series remained tied until the Senators scored in the twelfth inning of Game 7, and won their first World Series victory.

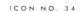

Ted Williams's Uniform

With a .344 lifetime average and 521 home runs, Boston Red Sox slugger Ted Williams is arguably the greatest hitter that ever lived. On top of his 1960 home jersey are Williams's glasses from the 1951 season and the bat he used to hit his last home run in his last at bat on September 28, 1960, at Fenway Park.

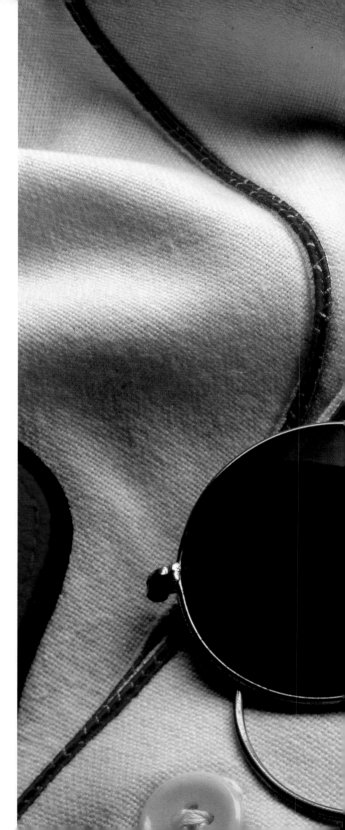

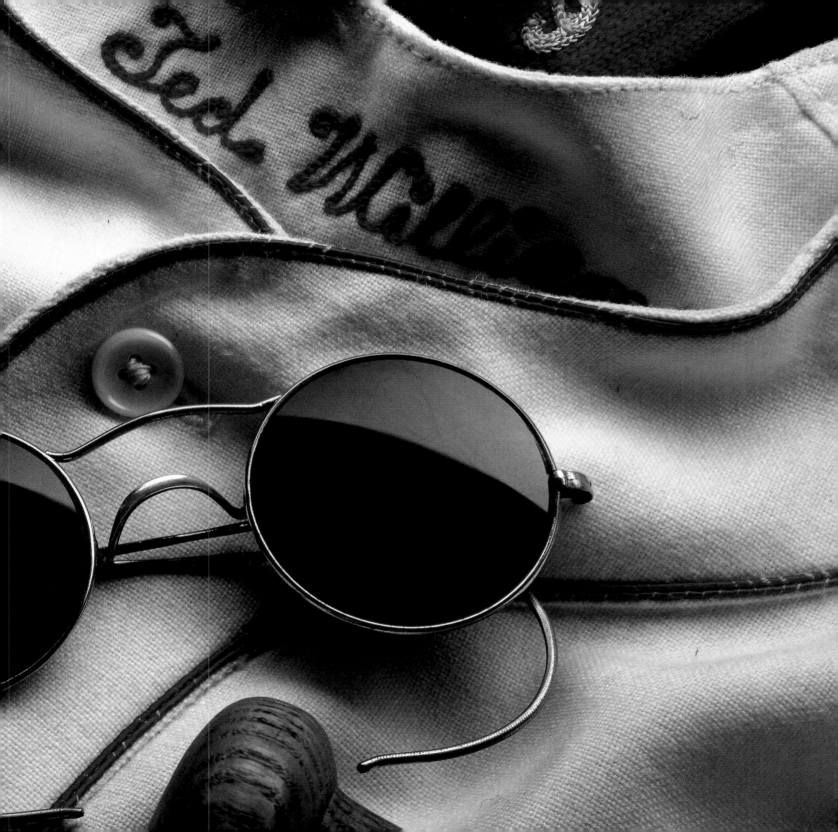

Early Baseball Cards

In the mid-1880s tobacco companies began producing baseball cards featuring leading players of the day. Inserted into packs of cigarettes, the cards helped to boost sales as well as stiffen the packaging. By 1914, candy companies began noticing that kids were asking older men who smoked if they could have the cards, and began offering them as a premium themselves.

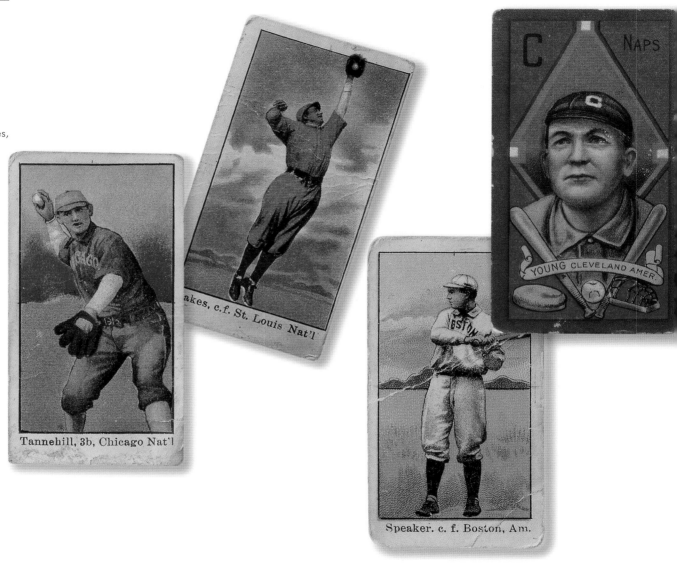

Tannehill, 3b, Chicago Nat'l

...akes, c.f. St. Louis Nat'l

Speaker. c. f. Boston, Am.

C NAPS

YOUNG CLEVELAND AMER.

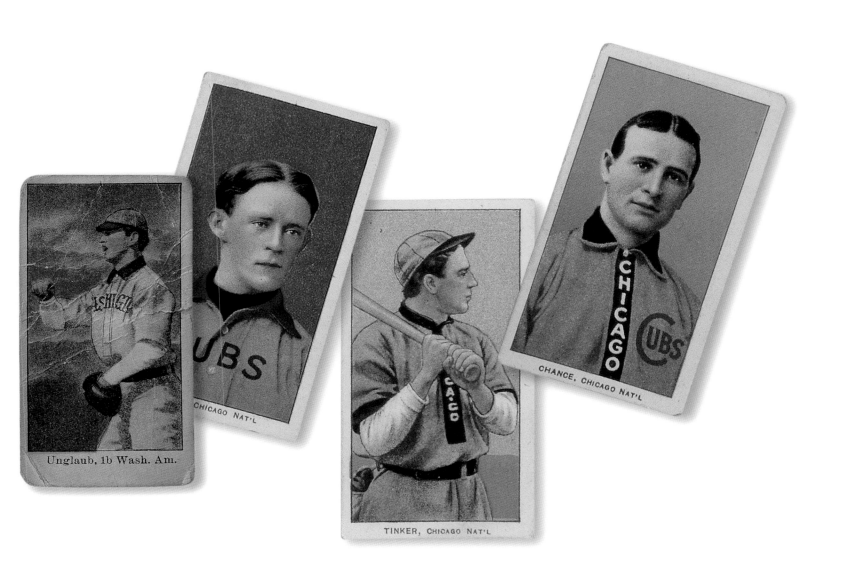

Unglaub, 1b Wash. Am.

CHICAGO NAT'L

TINKER, CHICAGO NAT'L

CHANCE, CHICAGO NAT'L

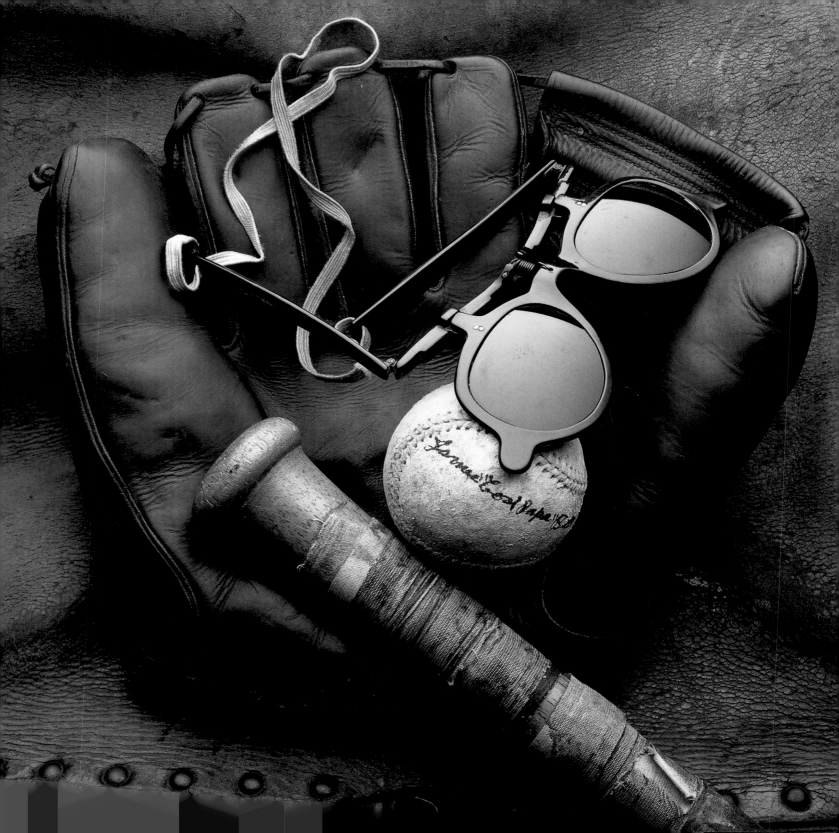

**Cool Papa
Bell's Gear**

James "Cool Papa"
Bell, whose gear is
shown here, spent most
of his career playing
in the Negro leagues,
although he had the
skill of a major league
player. Reputedly
the fastest man in base-
ball, Cool Papa was
clocked in 1924 as
circling the bases in
twelve seconds flat.
During his career, he
stole approximately
170 bases and had
multiple .400 seasons.
His career in the Negro
leagues ended in 1950.

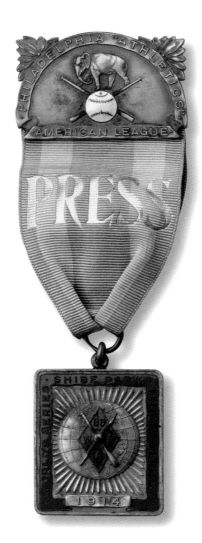

Press Pin

The 1914 media
pin for the Philadelphia
Athletics featured a
white elephant, which
part owner/manager
Connie Mack defiantly
adopted as the team's
logo after New York
Giants manager John
McGraw called the
Athletics "a white ele-
phant nobody wanted."

**Major
League Patches**

All thirty teams in
the major leagues
have their own brand
identities. The ones
for the Chicago Cubs,
Philadelphia Phillies,
and Pittsburgh Pirates
date back to the late
nineteenth century.

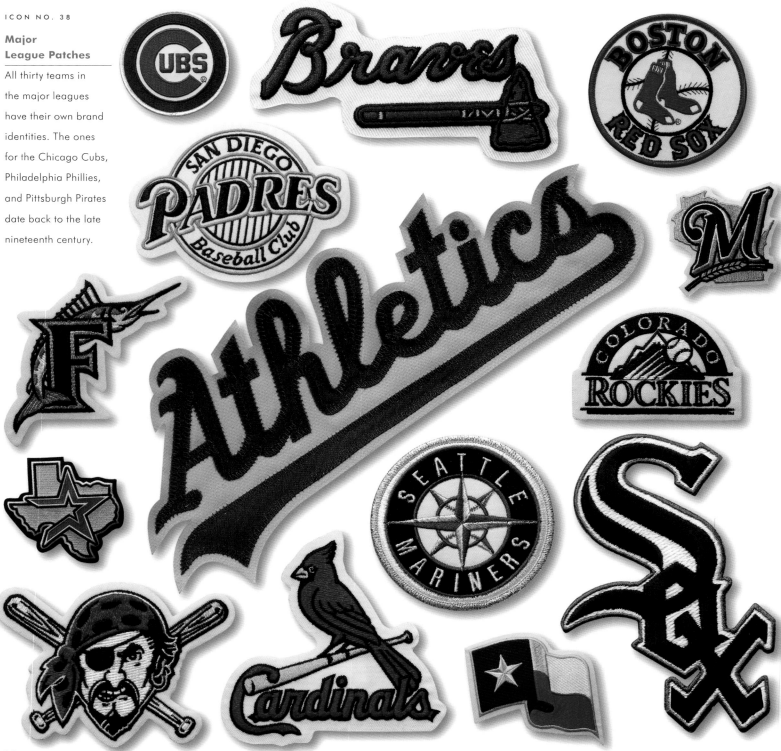

Tobacco Pins

Between 1910 and 1912, the American Tobacco Company issued a series of baseball pins and distributed them free with packs of cigarettes. Today they are highly collectible.

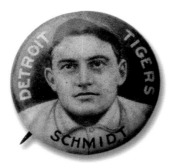

Charles "Boss" Schmidt,
Detroit Tigers, 1906–1911

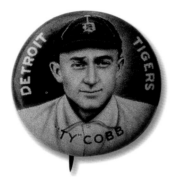

Ty "the Georgia Peach" Cobb,
Detroit Tigers, 1905–1926

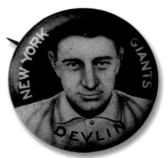

Art Devlin,
New York Giants, 1904–1911

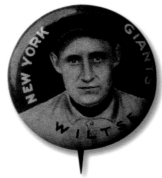

Hooks Wiltse,
New York Giants, 1904–1914

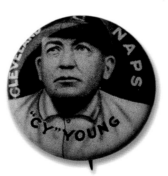

Cy Young,
Cleveland Naps, 1909–1911

ICON NO. 40

Willie Mays's Shoes

Giants center fielder Willie Mays, who won twelve consecutive Gold Glove Awards for his outfield defense, was also an excellent baserunner. During his twenty-two-year career, he stole 338 bases and tallied 660 home runs. From 1958 through 1966, he produced eight consecutive seasons of over 100 runs and RBI.

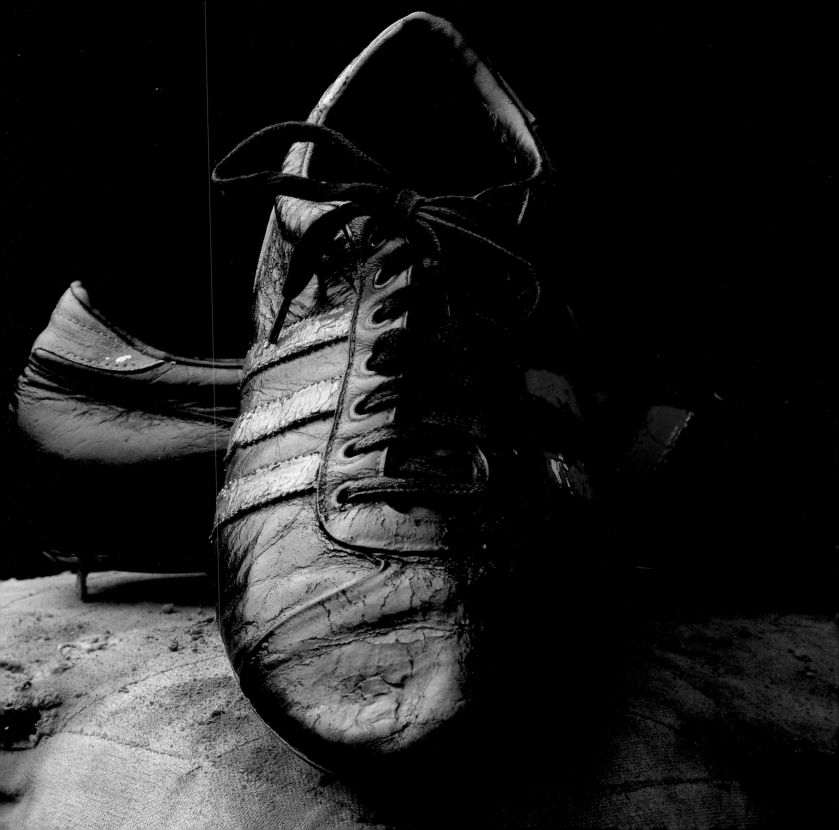

Umpire Signals

It is believed that the hand signals of umpires grew out of the signal flags used by ships at sea and by soldiers' hand signals at battle. However, the system of signals now used to call balls, strikes, and outs is attributed to Bisons outfielder William "Dummy" Hoy, the first deaf/mute to play in the major leagues. His career lasted from 1888 to 1902.

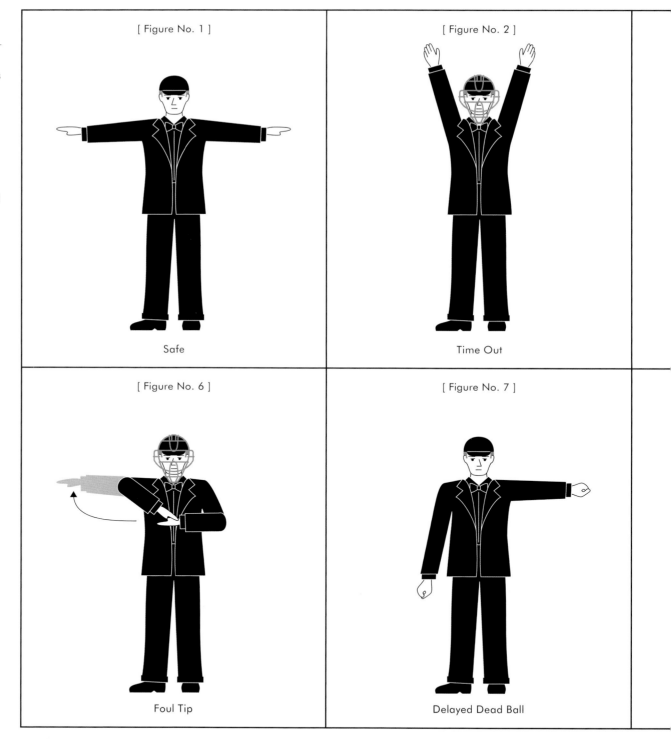

[Figure No. 1]

Safe

[Figure No. 2]

Time Out

[Figure No. 6]

Foul Tip

[Figure No. 7]

Delayed Dead Ball

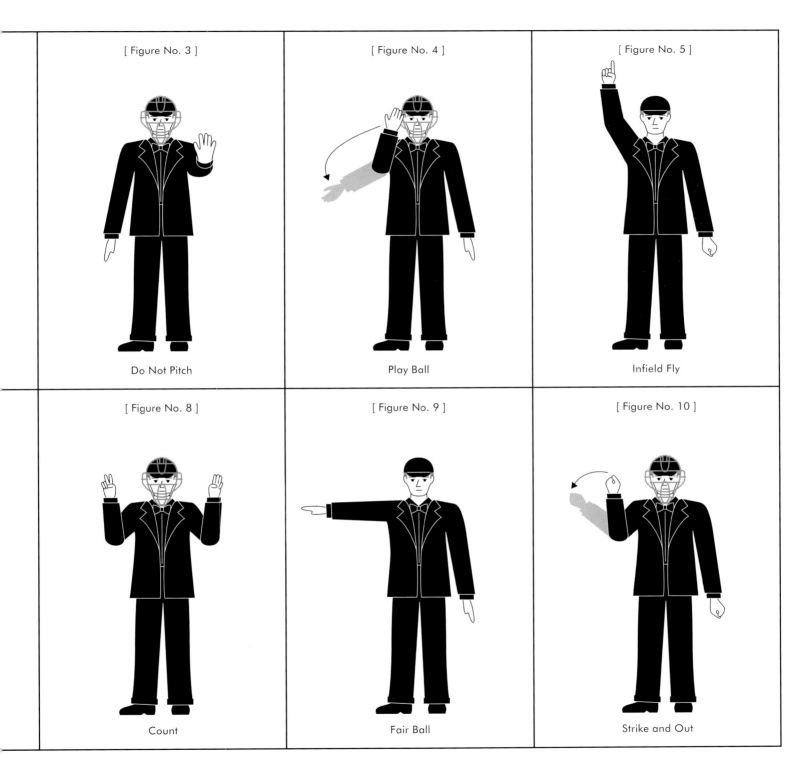

[Figure No. 3]

Do Not Pitch

[Figure No. 4]

Play Ball

[Figure No. 5]

Infield Fly

[Figure No. 8]

Count

[Figure No. 9]

Fair Ball

[Figure No. 10]

Strike and Out

**Commemorative
Patch and Ring**

After Pittsburgh Pirate
Roberto Clemente's
untimely death in
an airplane crash
while delivering relief
supplies to Nicaraguan
earthquake victims in
1972, his teammates
wore a commemorative
"21" patch in his
honor. It is shown here
with Clemente's 1971
World Series ring.

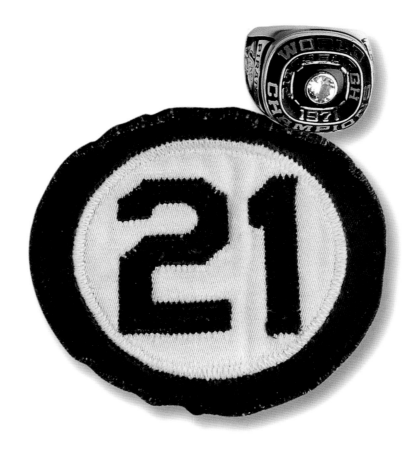

Yankees Program

The 1957 season was
the fifty-fifth for the
New York Yankees,
then managed by
Casey Stengel. The
team finished with a
record of 98–56,
winning their twenty-
third pennant, but
lost to the Milwaukee
Braves in seven games
in the World Series.

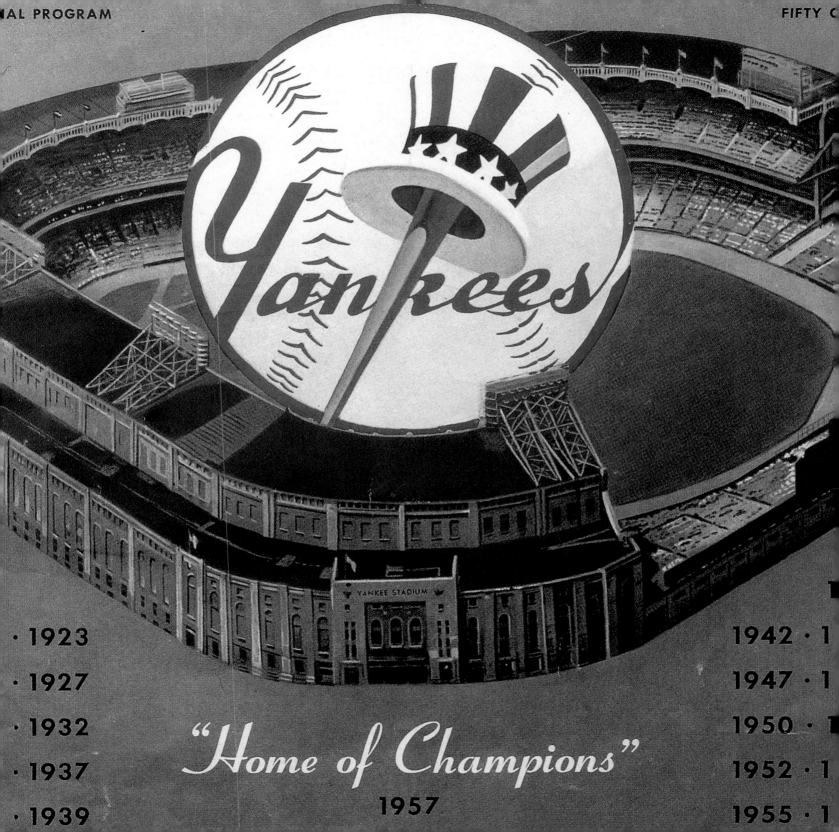

Yankees

· 1923 1942 · 1

· 1927 1947 · 1

· 1932 1950 · 1

· 1937 "Home of Champions" 1952 · 1

· 1939 1957 1955 · 1

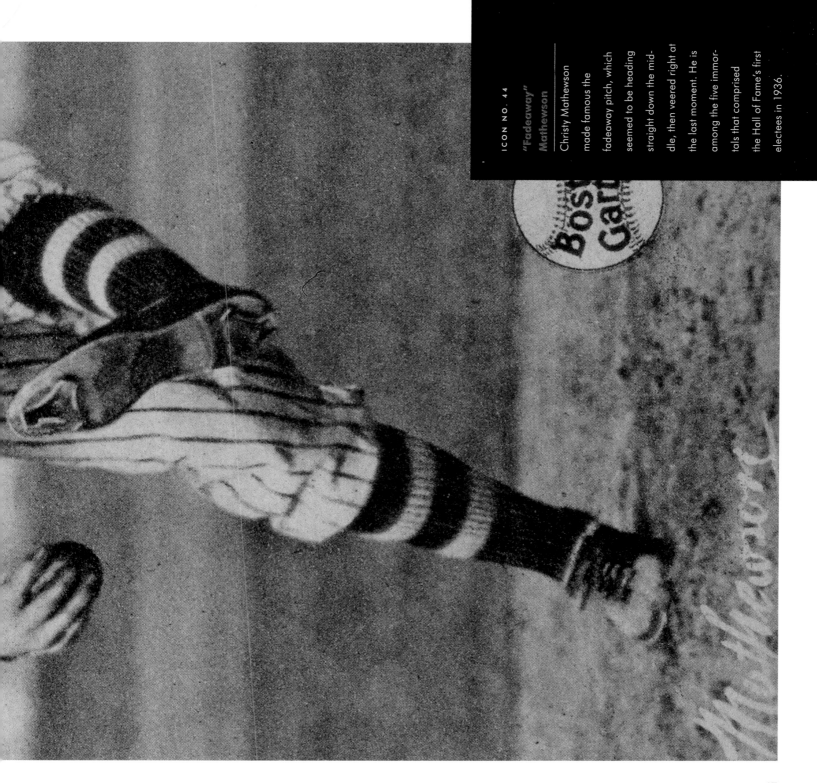

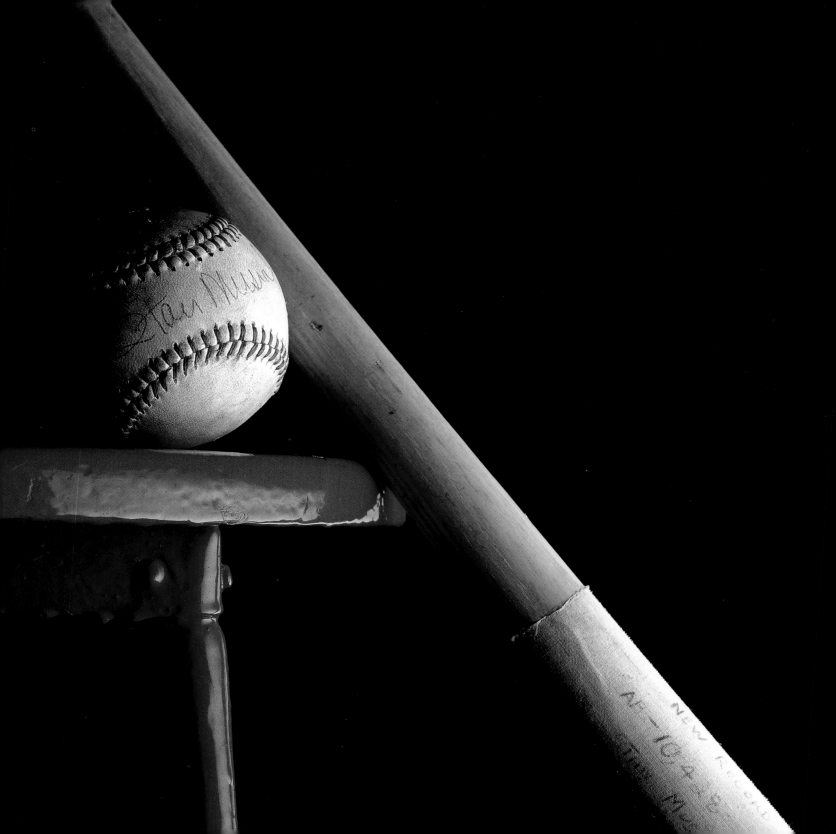

**Stan Musial's
Gear**

Three-time National
League Most Valuable
Player, St. Louis
Cardinal Stan Musial
was known for his
consistent hitting,
leading the league in
batting average seven
times. He is one of
only two players to
hit five home runs in
a single day. He did
it in a doubleheader
against the New York
Giants in 1954.

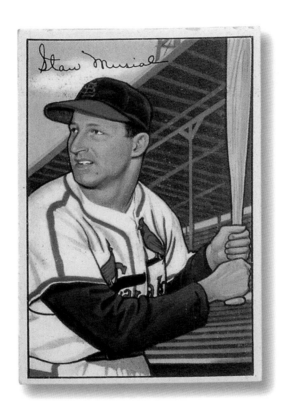

Bowman Card

A paper shortage
during World War II
brought baseball card
production to a virtual
halt. The Bowman
Gum Company was
one of the first to
resume production in
1948. It issued this Stan
Musial card in 1952.

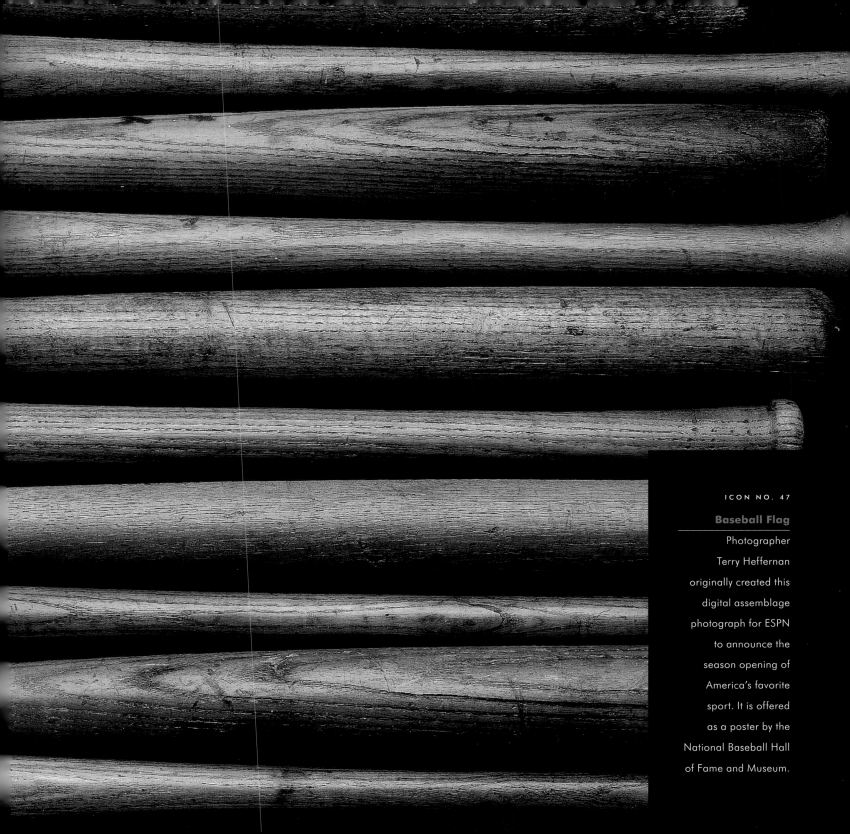

ICON NO. 47

Baseball Flag

Photographer Terry Heffernan originally created this digital assemblage photograph for ESPN to announce the season opening of America's favorite sport. It is offered as a poster by the National Baseball Hall of Fame and Museum.

Night Game Ticket

The introduction of
lights to baseball
stadiums transformed
the sport. The first
major league night
game happened in
1935, with President
Franklin D. Roosevelt
throwing the switch
from the White House
to light Crosley Field.
In 1938, Ebbets Field
proudly touted its
night game with an
electric light shown
on its tickets.

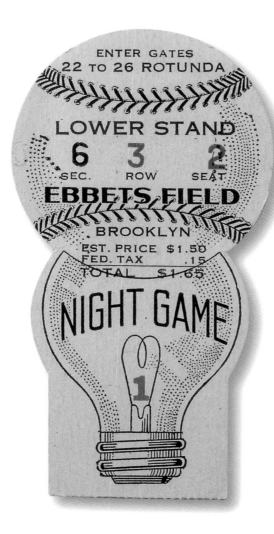

**Cy Young's
Memorabilia**

Between 1901 and
1908, Cy Young
played for the
American League's
Boston Americans
(renamed the Red Sox
in 1908). After pitch-
ing a perfect game
in 1904, teammates
presented him with
a pipe, shown
here with his glove
and commemorative
scrapbook, and the ball
he used to record his
500th win in 1910.

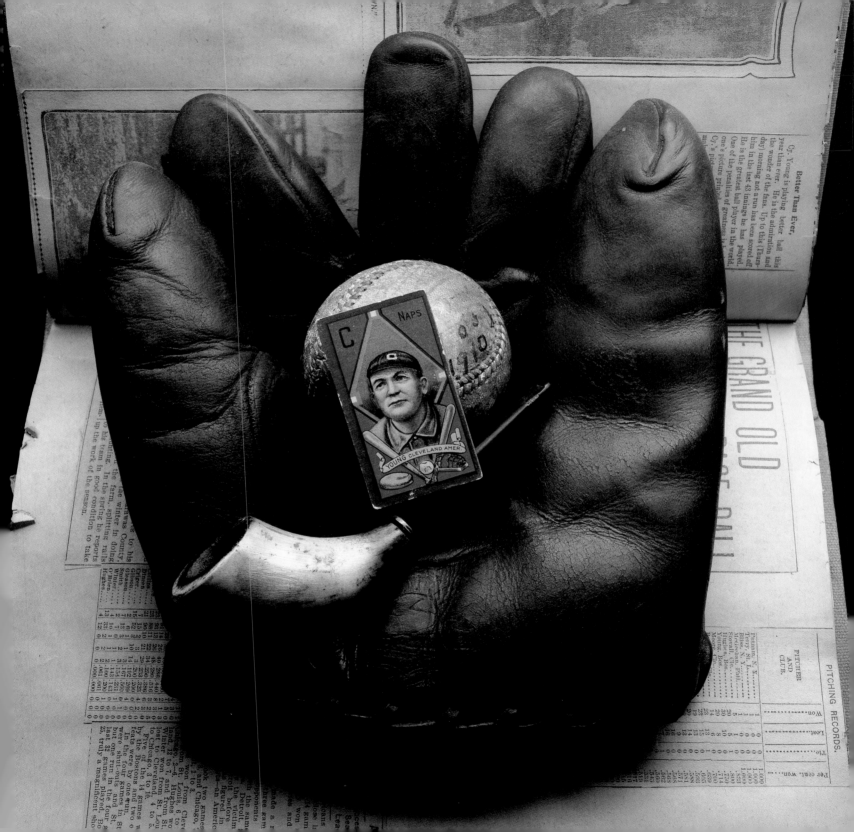

World Series Patch

The World Series between the major leagues began in 1903. Other tournaments preceded it, including an 1884 three-game "Championship of the United States" series, which reporters hailed as a "world" series, a title that stuck.

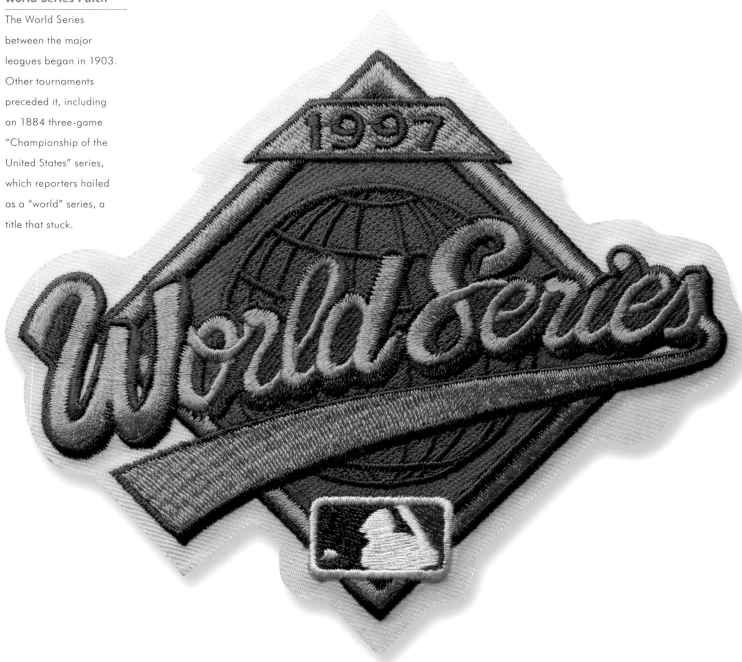

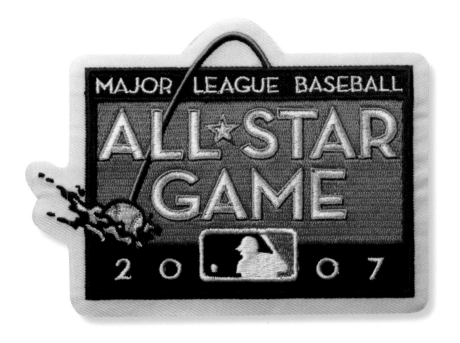

**All-Star
Game Patch**

The All-Star Game,
first held in Chicago's
Comiskey Park in
1933 in conjunction
with the Century of
Progress Exposition,
was an exhibition match
pitting the best play-
ers from the National
League against the
best of the American
League. Today,
fans cast ballots for
the starting lineup.

Paws the Tiger

Over the years most
major league teams
have adopted mascots.
Paws the Tiger is the
official mascot of the
Detroit Tigers. Other
famous mascots
include the chicken
for the San Diego
Padres, a parrot for
the Pittsburgh Pirates,
and Billy the Marlin for
the Florida Marlins.

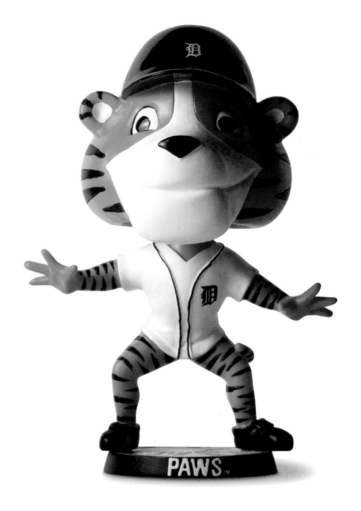

Chief Wahoo

The Cleveland Naps
(named after star player
Nap Lajoie) changed
their name to the Indians
in 1915 to honor Louis
Sockalexis, a Penobscot
Indian who played for
the Cleveland in 1897.
The Chief Wahoo logo
was conceived in 1947.

Ball Ass'n.

Ticket Book

This elegant leather-bound booklet, containing free passes to the Detroit Tigers games at Bennett Park, was given to club officials and VIPs circa 1910·

Lee Magee Pennant

Lee Magee was a player-manager for the Federal League's Brooklyn Tip-Tops in 1915. His career came to an abrupt end in 1920 when he admitted that he tried to "toss" a game with the Boston Braves when he was with the Cincinnati Reds in 1918.

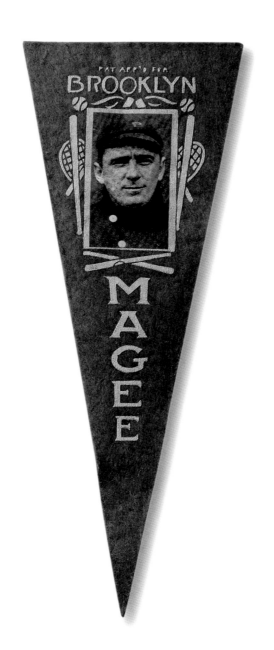

Player's Contract

After winning the American League's Most Valuable Player Award for the second time in 1924, Walter Johnson was signed to a hefty $20,000 player's contract. This was a major leap from his first contract in 1907 for $350 a month, a $100 bonus, and train fare to Washington.

IMPORTANT NOTICE

The attention of both Club and Player is specifically directed to the following excerpt from Article II, Section 1, of the Major League Rules:

"No club shall make a contract different from the uniform contract or a contract containing a non-reserve clause, except with the written approval of the Advisory Council. All contracts shall be in duplicate and the player shall retain a counterpart original. The making of any agreement between a club and player not embodied in the contract shall subject both parties to discipline by the Commissioner."

American League of Professional Baseball Clubs

UNIFORM PLAYER'S CONTRACT

Parties The *Washington American League Base Ball Club*

herein called the Club, and *Walter Johnson*,

of *Reno, Nevada*, herein called the Player.

Recital The Club is a member of the American League of Professional Baseball Clubs. As such, and jointly with the other members of the League, it is a party to agreements and rules with the National League of Professional Baseball Clubs and its constituent clubs, and with the National Association of Professional Baseball Leagues. The purpose of these agreements and rules is to insure to the public whole-some and high-class professional baseball by defining the relations between club and player, between and club, between league and league and by vesting in a designated Commissioner broad po control and discipline, and of decision in case of disputes.

Agreement In view of the facts above recited the parties agree as follows:

Employment 1. The Club will pay the Player an aggregate salary of $20000.00 skilled services during the playing season of 1925, including the World's Series or any series in which the Club may participate and in any receipts of which the Player may are.

Salary 2. The salary above provided for shall be paid by the Cl
In semi-monthly instalments after the commencement period covered by this contract, unless this contract shall be terminated by the Club while the Pl "abroad" with the Club for the purpose of playing games, in which event the amount then due shall be paid on the first week-day after the return "home" of the Club.

Loyalty 3. The Player will faithfully serve the Club or any other Club to which, in conformity with the agreements above recited, this contract may be assigned, and pledges himself to the American public to conform to high standards of personal conduct, of fair play and good sportsmanship.

Service 4. The Player will not play during 1925 otherwise than for the Club or for such other Clubs as

WORLD SERIES

BROOKLYN DODGERS vs BOSTON RED SOX

AT EBBETS FIELD

**1946 World
Series Poster**

The St. Louis Cardinals
won the best-of-three
play-offs over the
Brooklyn Dodgers and
went on to face the
Red Sox in the 1946
World Series. The
Cardinals triumphed
over the Red Sox to
win the Series when
Enos Slaughter made
his tiebreaking "mad
dash" for home in the
bottom of the eighth
inning of Game 7.

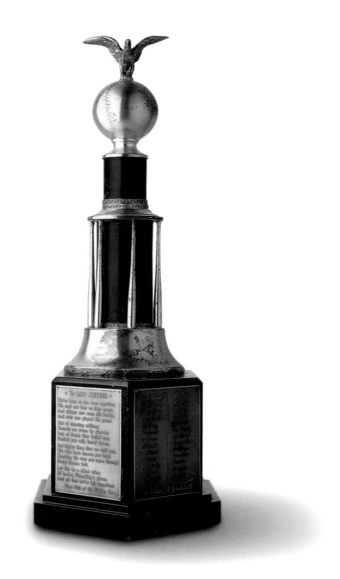

Lou Gehrig Trophy

July 4, 1939, was
declared Lou Gehrig
Day, and Gehrig's
Yankee teammates
presented the ailing
player with this trophy,
inscribed with a poem
written by New York
sportswriter John
Kieran. Gehrig died
from amyotrophic
lateral sclerosis, now
often referred to as
Lou Gehrig's disease,
two years later.

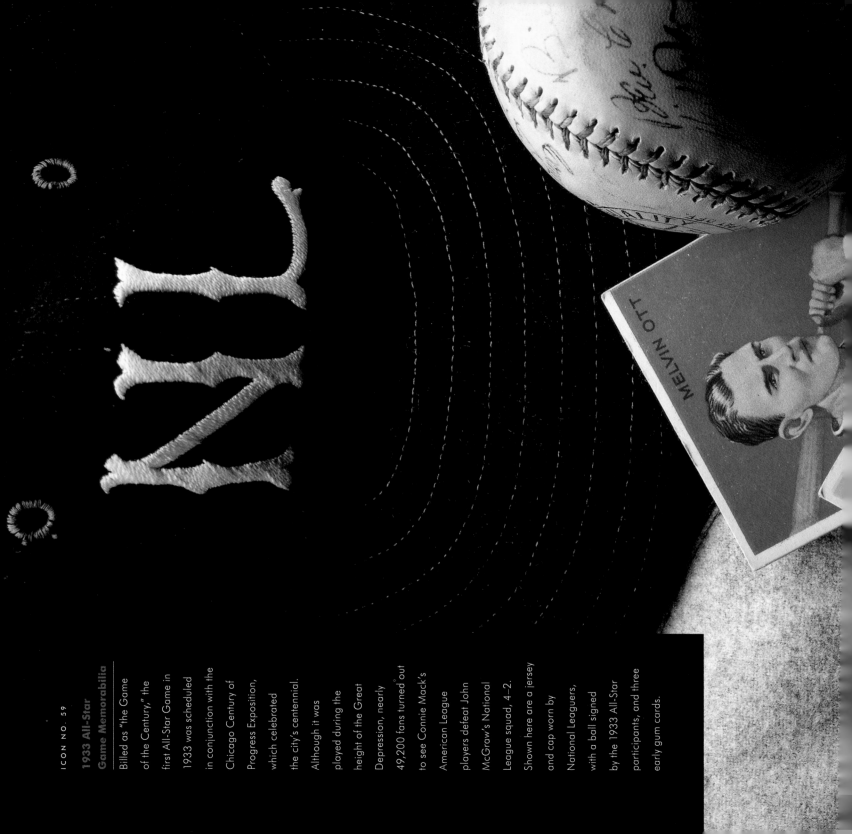

**1933 All-Star
Game Memorabilia**

Billed as "the Game
of the Century," the
first All-Star Game in
1933 was scheduled
in conjunction with the
Chicago Century of
Progress Exposition,
which celebrated
the city's centennial.
Although it was
played during the
height of the Great
Depression, nearly
49,200 fans turned out
to see Connie Mack's
American League
players defeat John
McGraw's National
League squad, 4–2.
Shown here are a jersey
and cap worn by
National Leaguers,
with a ball signed
by the 1933 All-Star
participants, and three
early gum cards.

MELVIN OTT

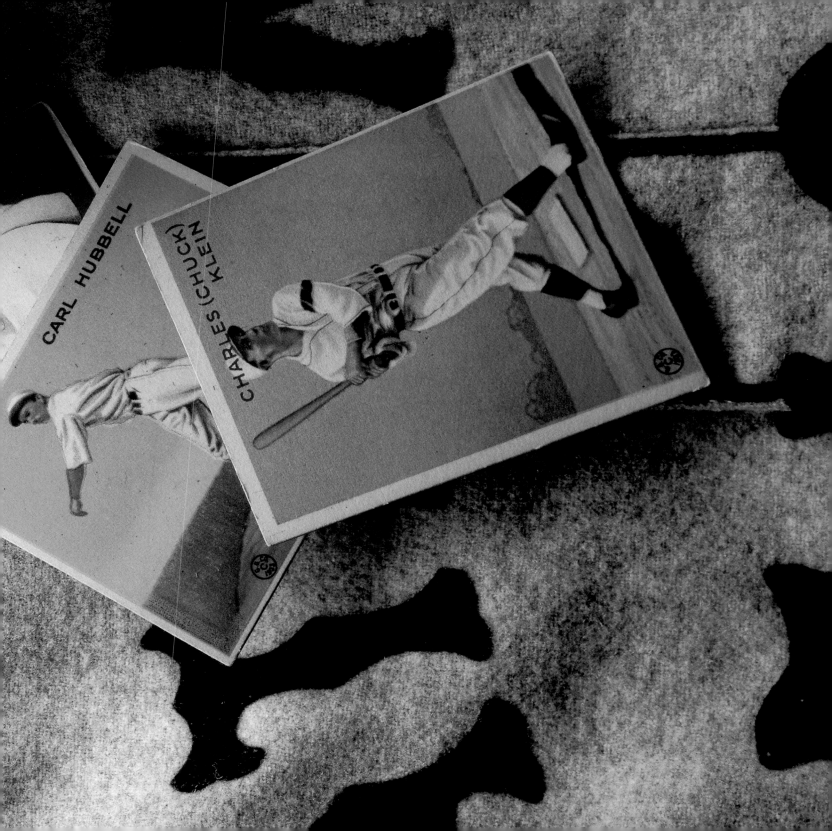

ICON NO. 60

Mickey Mantle
Cards

Bowman Gum
Company issued the
Mickey Mantle card
(#253) at the bottom in
1951, Mantle's rookie
year with the New York
Yankees, and the one
on top (#101) in 1952.
A mint condition Mantle
rookie card now sells
at auction in the seven
thousand dollar range.

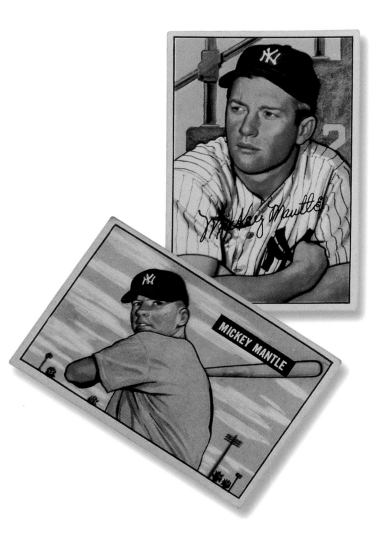

ICON NO. 61

Mickey Cochrane's
Catcher's Gear

One of the greatest
offensive catchers ever,
Mickey Cochrane
went nine seasons of
hitting .300 and six
seasons leading the
American League's
catchers in putouts. His
career came to an
abrupt end in 1937,
when a beaning
caused a serious head
injury. This is the gear
used by Cochrane
sometime between
1925 and 1937.

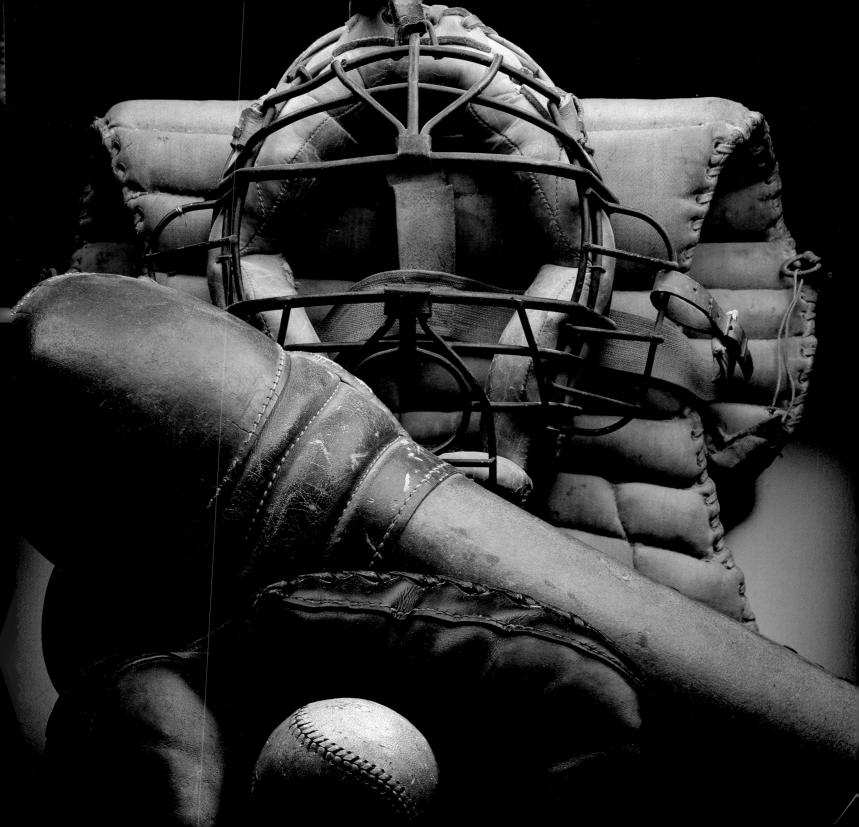

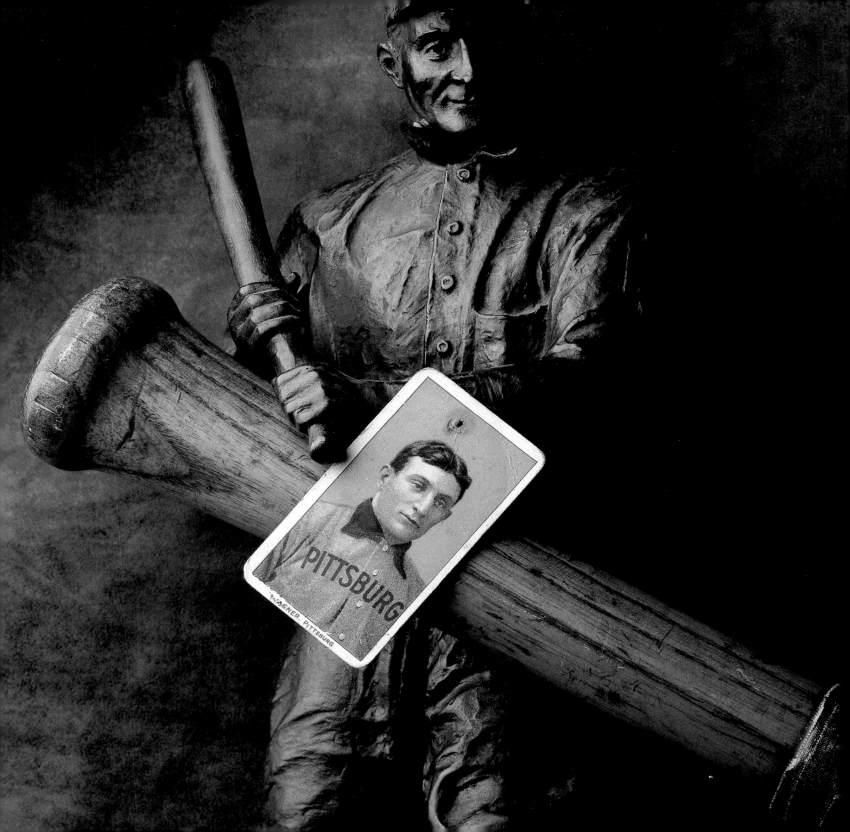

Coveted Card

One of the rarest
baseball cards in
existence is that of
Honus Wagner, who
helped the Pittsburgh
Pirates win pennants
in 1901, 1902, 1903,
and 1909. It is said that
Wagner did not want
children to have to buy
tobacco products to get
his card, so he asked
that it be withdrawn.
At auction in 2007,
a Wagner card sold
for $2.35 million.

**Record-Breaking
Fastball**

Walter Johnson's
sidearm throw was
reputed to travel at
speeds of over 100
miles per hour. From
his first pitch in 1907
to his retirement in
1927, Johnson won
417 games for the
Washington Senators.

ICON NO. 64

"Big Train"
Johnson Statuette

Sounding like a locomotive whistling through town, the fastball pitch of Walter Perry Johnson earned him the nickname "Big Train." During his years with the Washington Senators, he led the American League in strikeouts for twelve seasons, totaling 3,512 lifetime. This 18-inch plaster statuette in gold leaf was completed in 1913, the year he went 36–7.

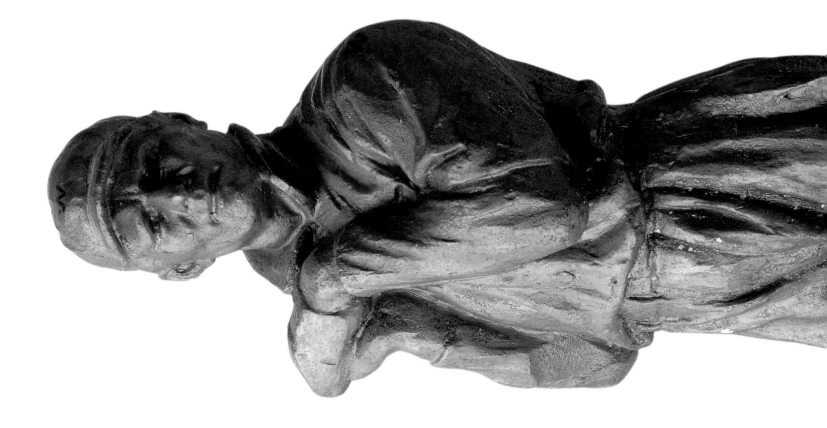

70

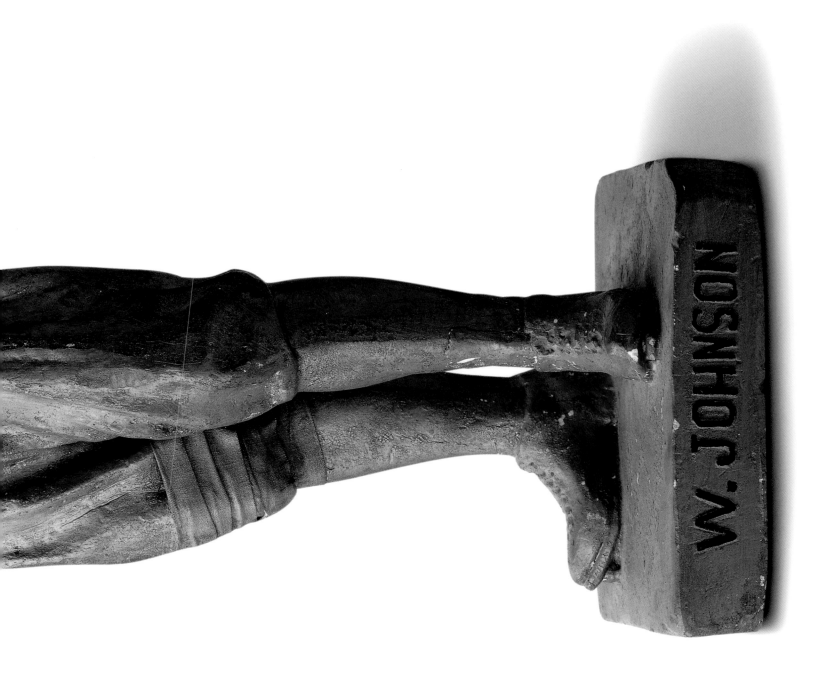

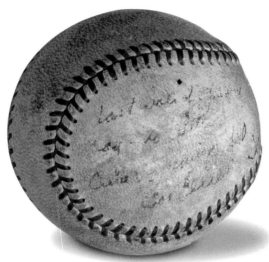

Chicago, April 16, 1940

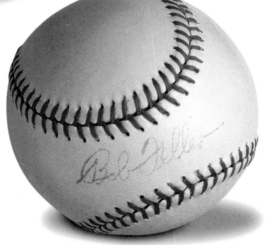

New York, April 30, 1946

**Bob Feller's
No-Hitters**

These are balls used
by Cleveland Indian
Bob Feller to pitch his
three no-hit games:
top, a 1–0 Cleveland
victory over Chicago on
April 16, 1940; middle,
a 1–0 win over New
York on April 30, 1946;
bottom, a 2–1 win over
Detroit on July 1, 1951.

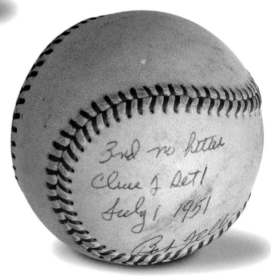

Detroit, July 1, 1951

Warren Spahn

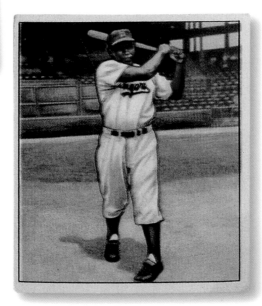

Jackie Robinson

Mid-Century Baseball Cards

Bowman Gum, a Philadelphia-based bubble gum manufacturer, was the leading producer of baseball trading cards following World War II. Top left is a 1949 card (#33) of Warren Spahn, middle is a 1950 card (#22) of Jackie Robinson, and bottom is a 1949 card (#24) of Stan Musial. The Bowman trading card brand was bought by Topps in 1956.

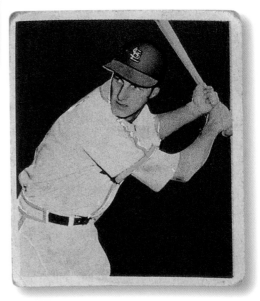

Stan Musial

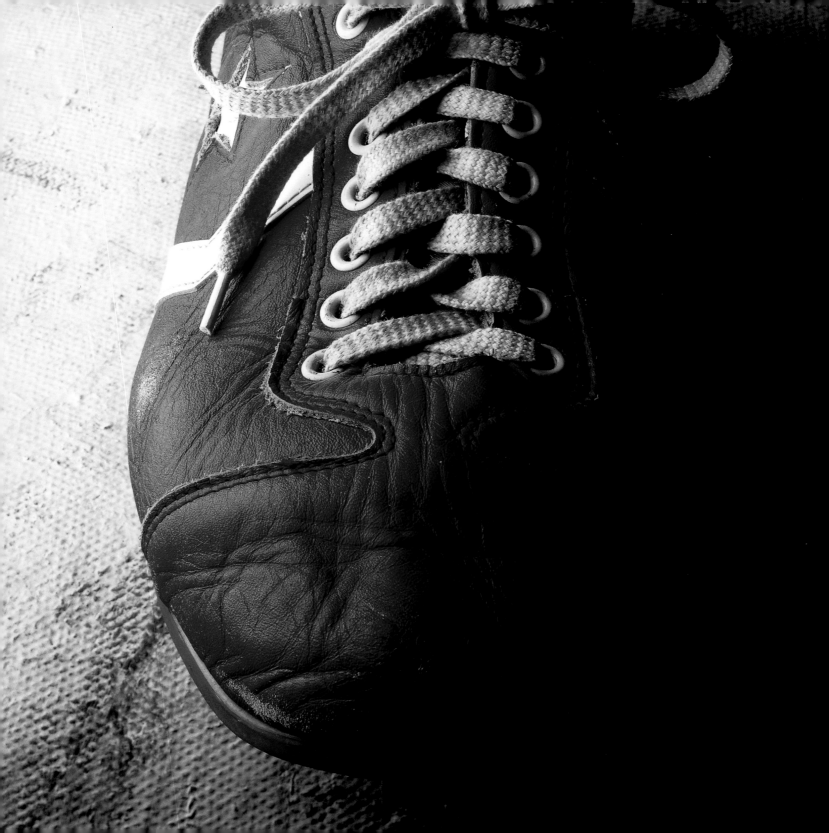

**Lou Brock's
Base-Stealing
Shoes**

In 1967, the St. Louis
Cardinals' Lou Brock
became the first player
to steal 50 bases and
hit 20 home runs in a
single season. He led
the National League
in steals eight times.

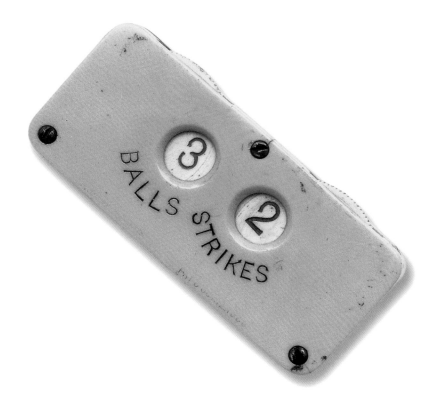

BALLS STRIKES
3
2

ICON NO. 68

Umpire's Indicator

This manually
advanced balls-and-
strikes indicator was
used by the renowned
umpire Tom Connolly,
who called the first
World Series in 1903,
one of eight Series in
which he officiated.

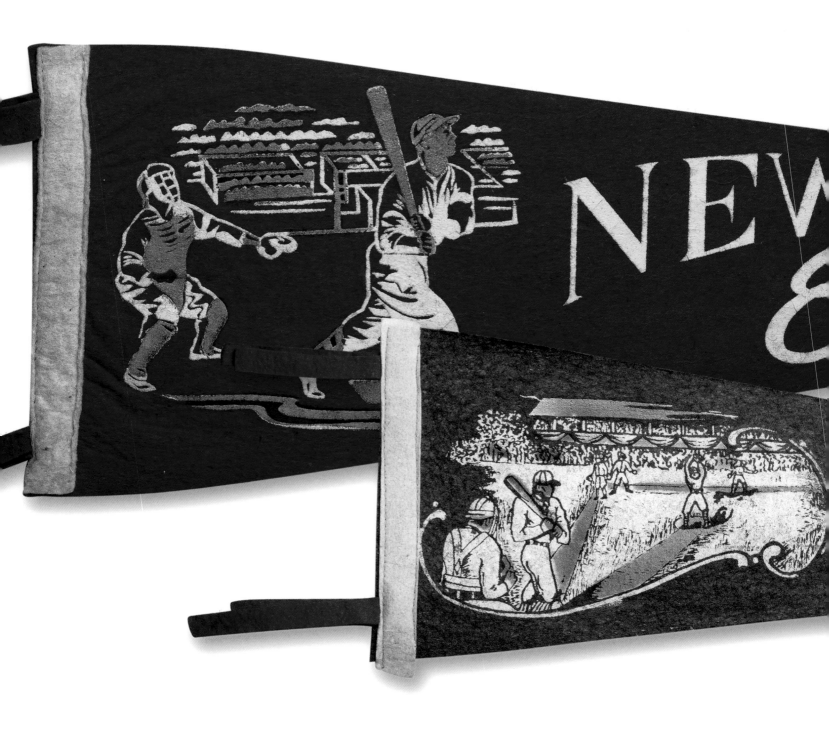

ARK
agles

BALTIMORE
ELITE GIANTS

ICON NOS. 69 & 70

**Negro League
Team Pennants**

The Newark Eagles
and the Baltimore Elite
Giants were part of the
Negro leagues. The
Eagles participated
in the second Negro
National League that
played from 1933 to
1948 and featured
several future Hall of
Famers including Larry
Doby and Monte Irvin.
Prior to becoming
the Baltimore Elite
Giants in 1938, the
team had been in
several other cities.

Federal League Score Card

In 1914 and 1915, the eight-team Federal League tried to establish an independent professional league in competition with the American and National Leagues. After the 1915 season, half of the Federal teams, including Brooklyn, were bought out by American and National League owners. The Brooklyn Tip-Tops team was named by owner Robert Ward after his Tip-Top Bakery.

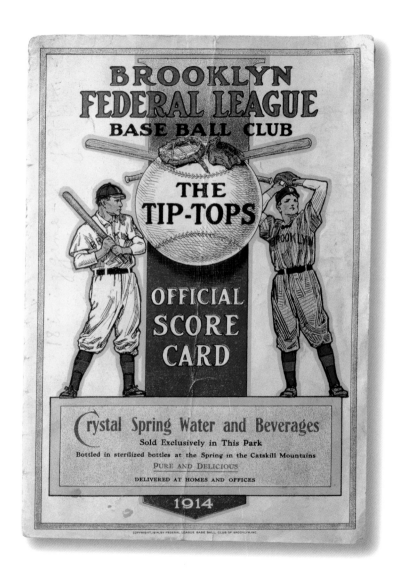

BROOKLYN FEDERAL LEAGUE BASE BALL CLUB

THE TIP-TOPS

OFFICIAL SCORE CARD

Crystal Spring Water and Beverages
Sold Exclusively in This Park
Bottled in sterilized bottles at the Spring in the Catskill Mountains
PURE AND DELICIOUS
DELIVERED AT HOMES AND OFFICES

1914

COPYRIGHT, 1914, BY FEDERAL LEAGUE BASE BALL CLUB OF BROOKLYN, INC.

Clemente's Gear

Roberto Clemente was the first Puerto Rican to win Most Valuable Player honors and the first Hispanic inducted into the Baseball Hall of Fame. The twelve-time All-Star was a Gold Glove right fielder for twelve straight years. Shown here are Clemente's locker chair from Forbes Field; the bat used for his 3,000th and last hit; and his cap from the 1971 championship season.

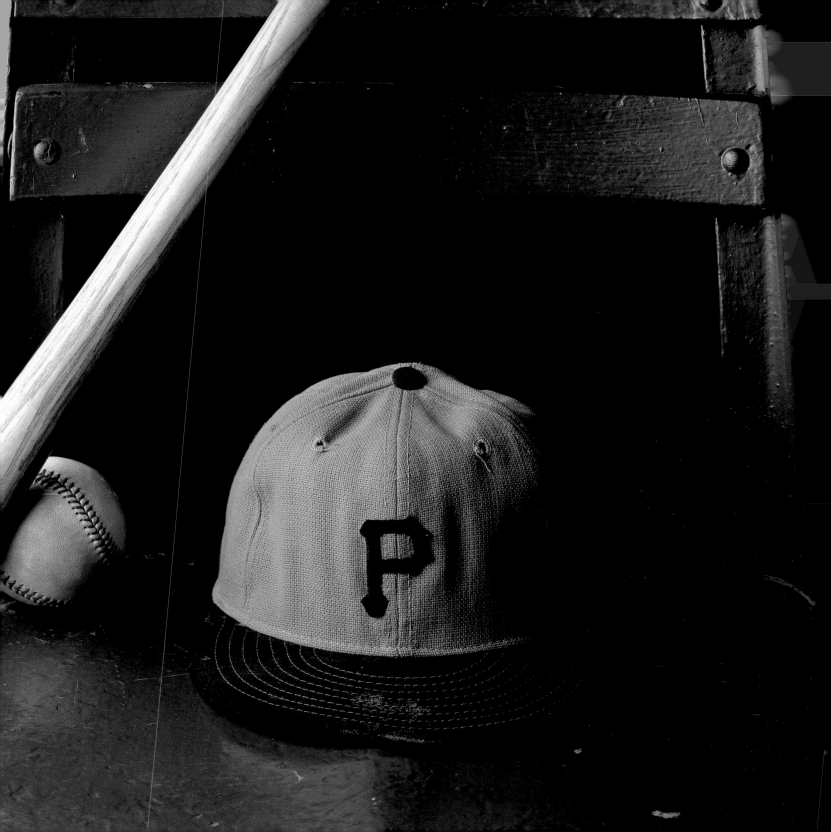

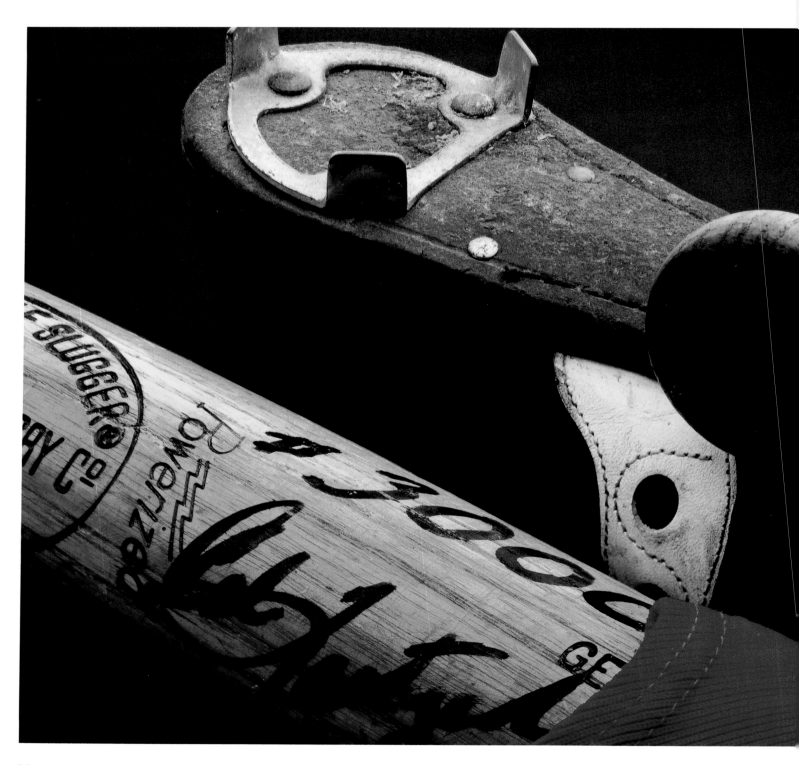

ICON NO. 73

Yastrzemski's Gear

In 1967, Carl "Yaz" Yastrzemski led the Boston Red Sox to the American League pennant for the first time in two decades. During his twenty-three-year career with the Red Sox, he amassed 452 home runs and 3,419 hits. He was voted the league's Most Valuable Player for the season and won the Triple Crown.

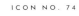

ICON NO. 74

Boston Red Stockings Pin

Early teams wore the same color uniforms and distinguished themselves by their stocking color. Boston's first professional team, founded in 1871, was called the Red Stockings. It became a charter member of the National League and today plays as the Atlanta Braves. The Boston Red Sox were never called the Red Stockings.

Ty Cobb Fan

Advertisers were
already distributing
premiums at major
league ball games
in 1913. This handheld
fan, featuring an illustra-
tion of "Georgia Peach"
Ty Cobb, was produced
by the American
Tobacco Company.

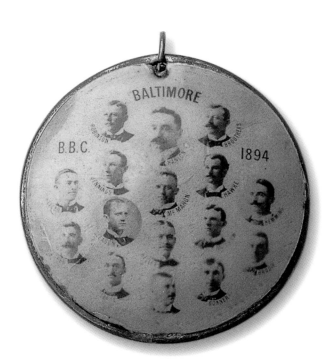

**Baltimore
Champions Pendant**

Cameo photographs
of all of the members
of the Baltimore
baseball club of 1894
are featured on this
pendant, which was
designed to be hung
on a ribbon much like
a military medal. The
back side proclaims
them the "Champions
of the World."

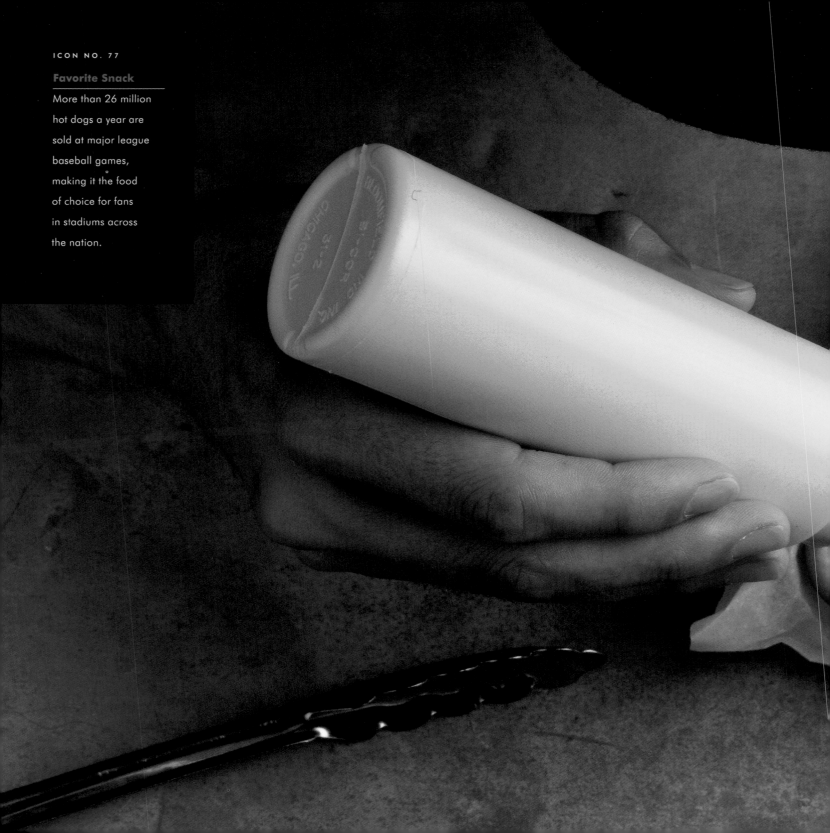

ICON NO. 77

Favorite Snack

More than 26 million
hot dogs a year are
sold at major league
baseball games,
making it the food
of choice for fans
in stadiums across
the nation.

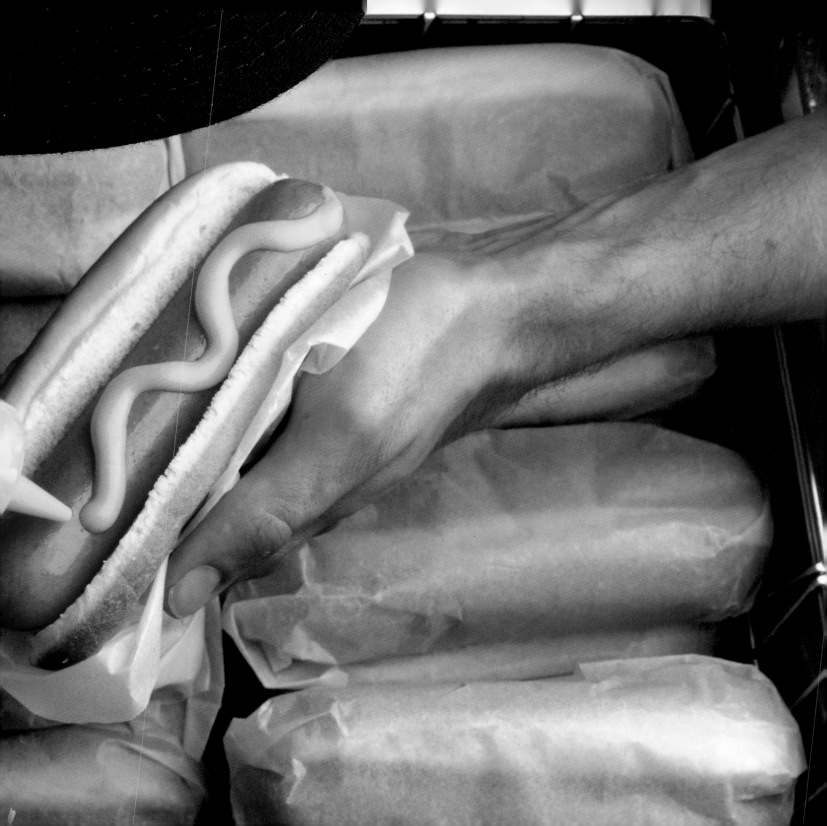

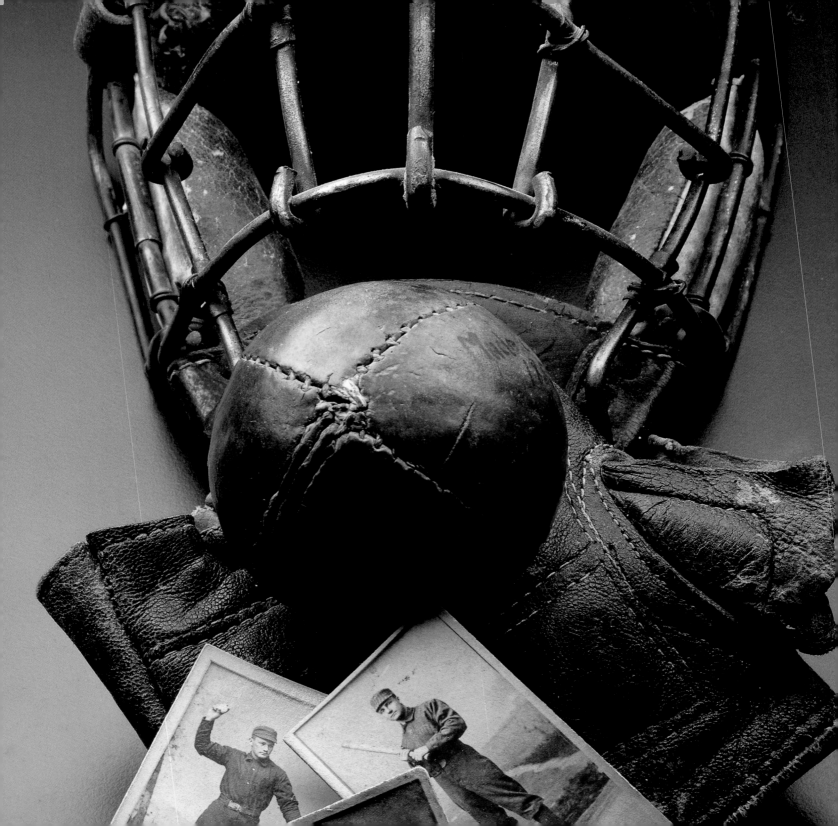

Early Equipment

In the late 1880s,
catchers wore a wire
face guard modeled
after a fencer's mask
and caught handmade
leather balls dubbed
"lemon peel" balls
because of the stitch-
ing pattern. They are
shown here with cards
from the 1887–1890
period, which were
included in Old Judge
and Gypsy Queen
cigarette packs. The
sepia photographs were
done by Brooklyn pho-
tographer Joseph Hall.

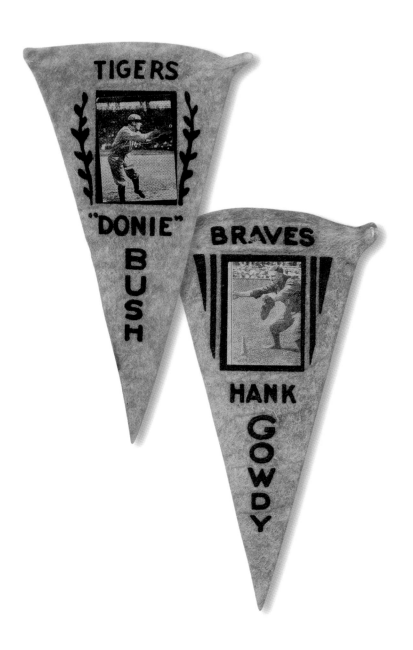

ICON NO. 79

**Pre–World War I
Pennants**

Shortstop Donie Bush
of the Detroit Tigers
and catcher/first base-
man Hank Gowdy
of the Boston Braves
were early twentieth
century players. Bush
still holds the record
for triple plays (9) in
a career and putouts
(425) in a season.
Gowdy is best remem-
bered for batting .545
in the historic upset
of the Philadelphia
Athletics in the 1914
World Series.

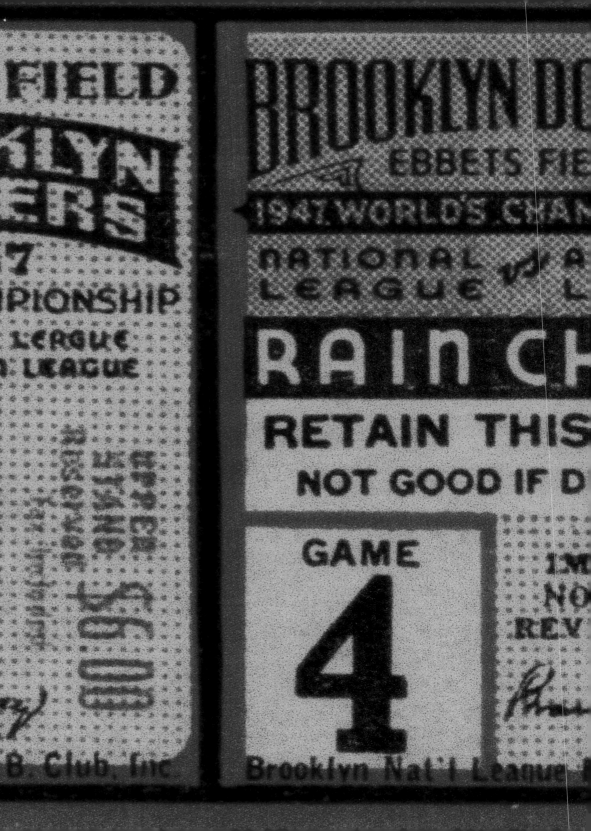

**1947 World
Series Ticket**

The 1947 World Series
matched the New
York Yankees with the
Brooklyn Dodgers, with
the Yankees winning
the Series in seven
games, its first win
since 1943 and its
eleventh championship
in team history.

GERS
CHAMPIONSHIP
AMERICAN
LEAGUE

ECK
CHECK
ACHED

SAD
RTANT
ES ON
SE SIDE.

eball Club, Inc.

UPPER STAND
RESERVED SEAT

SEC
20 6

ROW
6

SEAT
9

ENTER GATE D

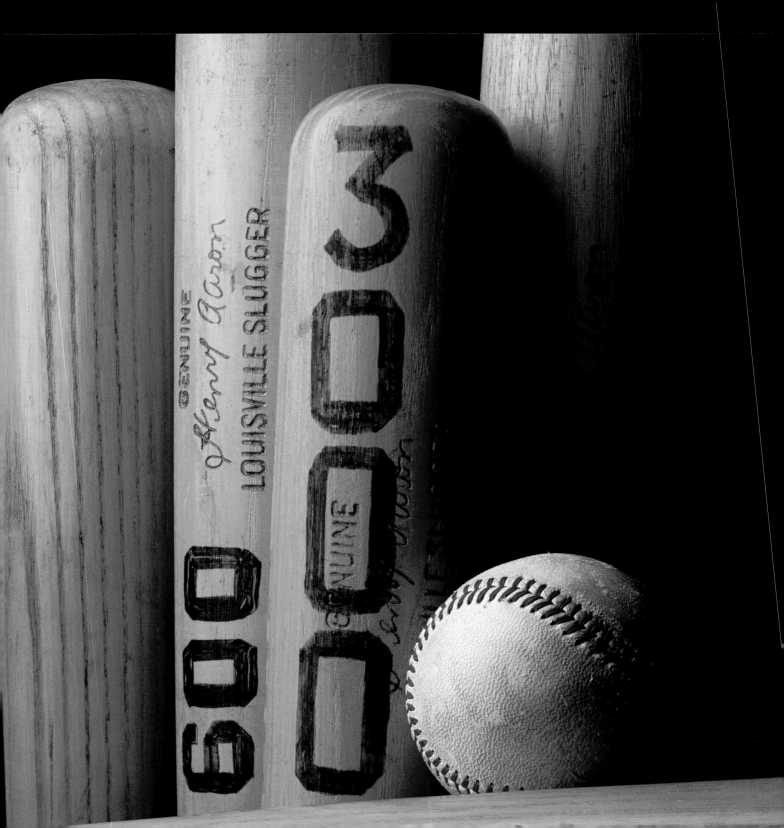

Hammerin' Hank's Bats

Said to hit home runs so low and hard that shortstops would jump for them, Hank Aaron toppled records time after time during his twenty-three years with the Milwaukee and Atlanta Braves and the Milwaukee Brewers. This collection of Aaron's bats includes the ones he used to hit home run numbers 600, 714 with ball, 716, and 717, and base hit number 3,000.

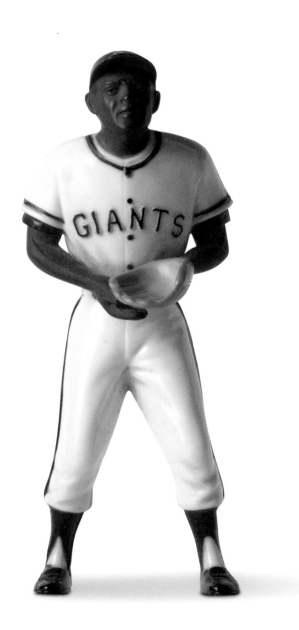

Willie Mays Figurine

Many consider Willie Mays to be the greatest all-around ball player ever. Mays ended his career with 660 home runs, two Most Valuable Player awards, and twenty-four All-Star appearances. The Giants' center fielder had a distinctive two-handed "basket" style of catching, which in the 1954 World Series led to one of the most remarkable defensive plays in the history of professional baseball.

**World Series
Press Pins**

For the World Series,
both teams issue
special pins to the
press and key officials.
Teams must decide
whether to produce
pins before the season
is over so that they
will be ready in
time for the World
Series. As a result,
"phantom" pins exist
for teams that failed
to win their league
championship. Today
press pins are still
being issued, but
the year is omitted
so they can be used
in the future.

ICON NO. 84

MVP Medal

Rogers "Rajah"
Hornsby is regarded
as baseball's greatest
right-handed hitter.
In 1925 and 1929, he
received the National
League's Most Valuable
Player award.

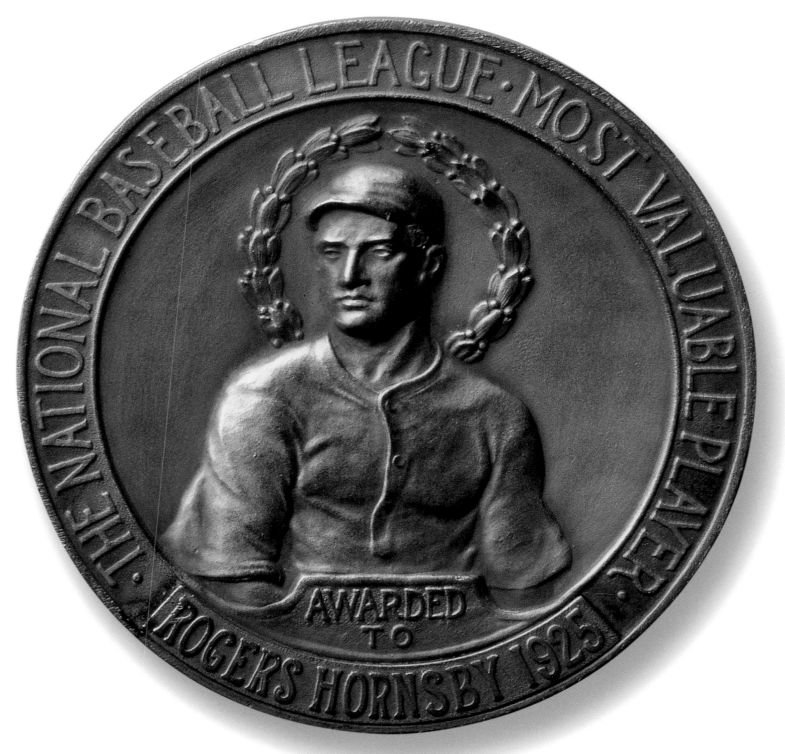

THE NATIONAL BASEBALL LEAGUE · MOST VALUABLE PLAYER ·

AWARDED
TO

ROGERS HORNSBY 1925

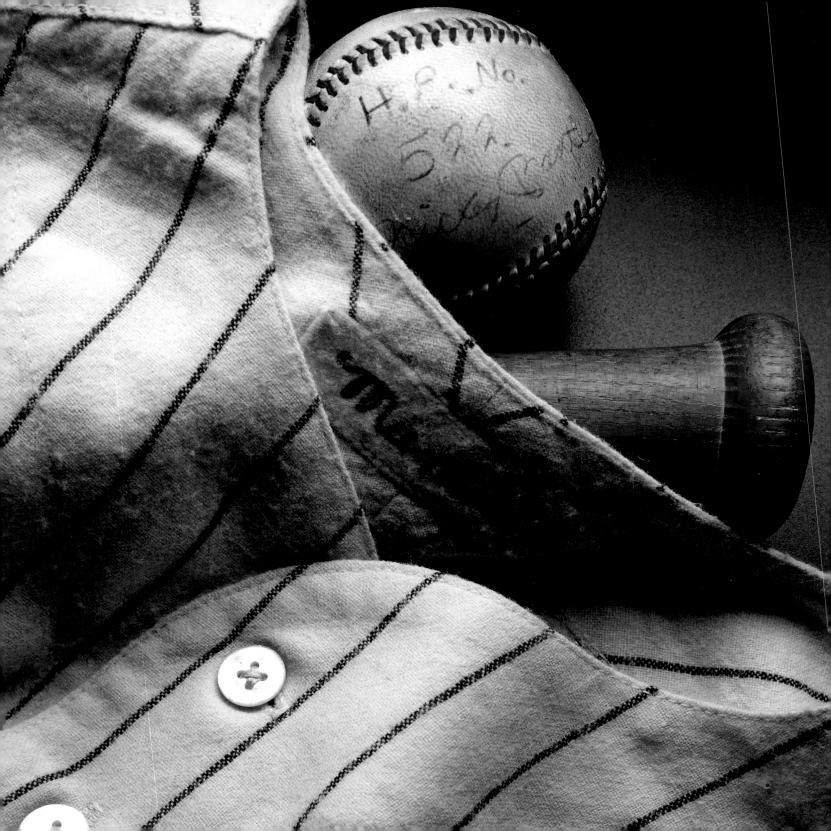

Mickey Mantle Memorabilia

New York Yankee Mickey Mantle was a switch-hitter known for hitting some of the longest home runs in major league history. At Yankee Stadium, he hit the roof façade five times, the only thing stopping the ball from sailing out of the park. He holds World Series records for home runs (18), RBI (40), runs (42), walks (43), extra base hits (26), and total bases (123).

Philadelphia Stars Pennant

The Philadelphia Stars was a Negro league baseball team founded in 1933. After being released by the Cleveland Indians, Satchel Paige played briefly with the Stars in 1950 before returning to the major leagues. The Stars disbanded after the 1952 season.

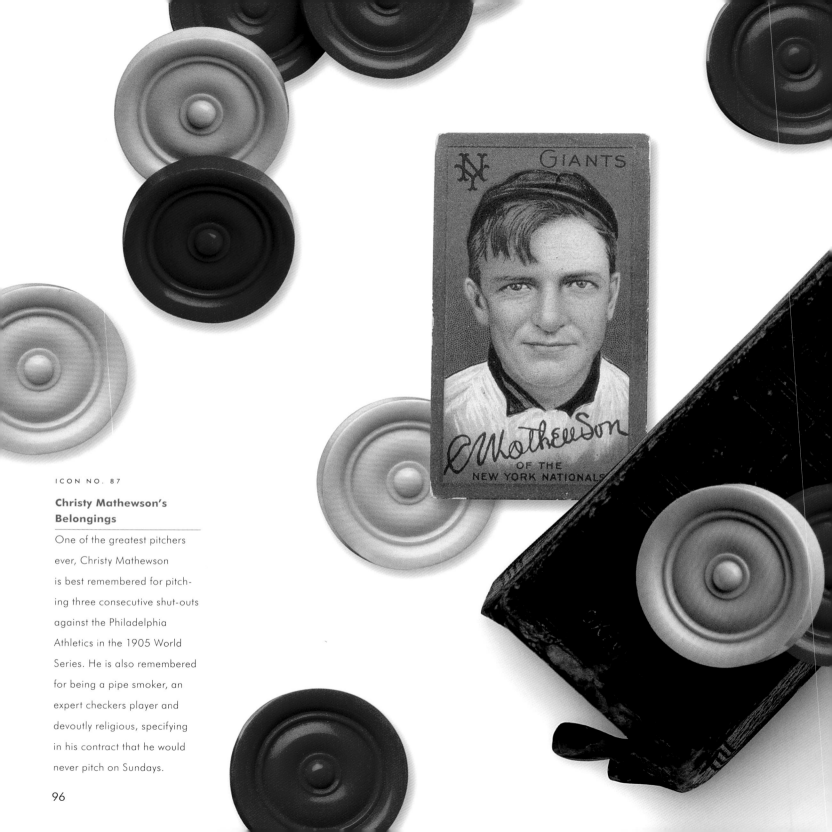

**Christy Mathewson's
Belongings**

One of the greatest pitchers
ever, Christy Mathewson
is best remembered for pitch-
ing three consecutive shut-outs
against the Philadelphia
Athletics in the 1905 World
Series. He is also remembered
for being a pipe smoker, an
expert checkers player and
devoutly religious, specifying
in his contract that he would
never pitch on Sundays.

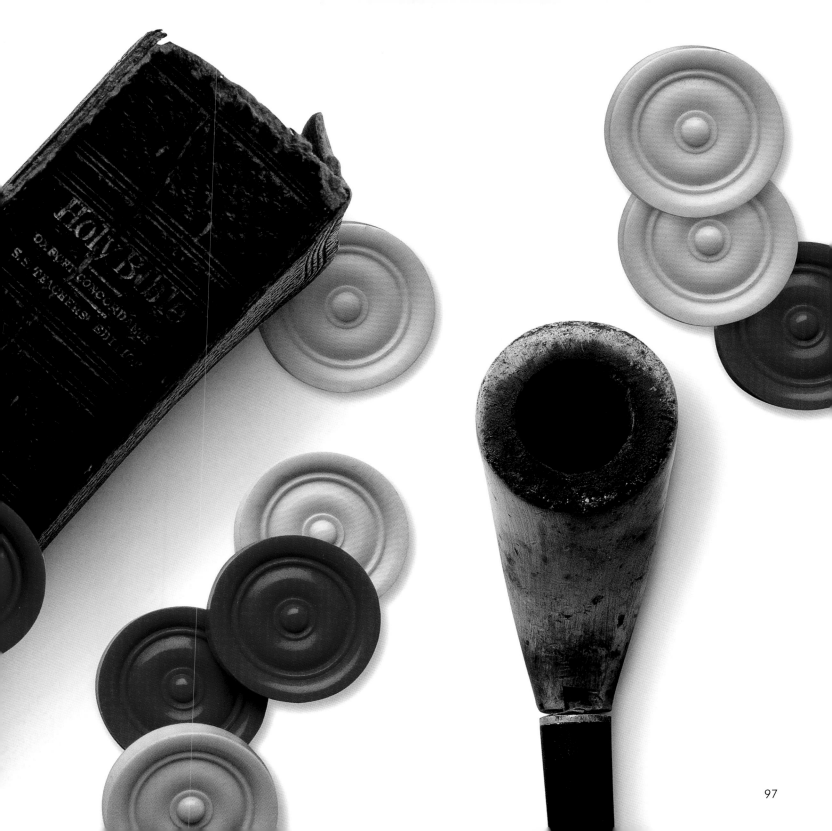

Gehrig's Keys

In the 1930s, Lou
Gehrig kept the keys to
his car and his locker
at Yankee Stadium with
him at all times. Often
called the greatest
first baseman ever,
Gehrig hit a record
twenty-three grand
slam home runs during
his career, and played
in 2,130 consecutive
games between 1925
and 1939. That streak
ended when he became
incapacitated by a fatal
neuromuscular disease.

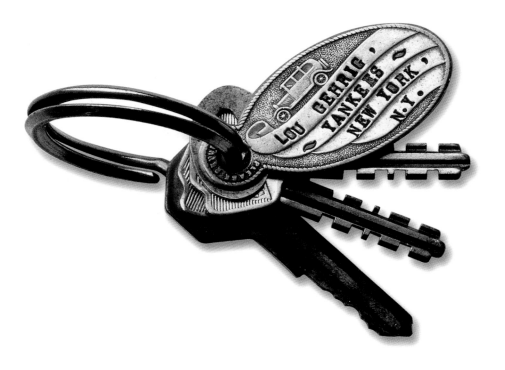

ICON NO. 89

King Carl's Crown

New York Giant's
pitcher "King" Carl
Hubbell achieved his
greatest fame in the
1934 All-Star Game
after striking out
American Leaguers
Babe Ruth, Lou
Gehrig, Jimmie Foxx,
Al Simmons, and Joe
Cronin in succession.
Between July 1936
and May 1937, he
won a record twenty-
four consecutive
games, a feat that
Seagrams lauded with
its trademark crown,
shown here with his
well-worn shoes, a ball
signed by the 1937
Giants, and a 1933
Goudey gum card.

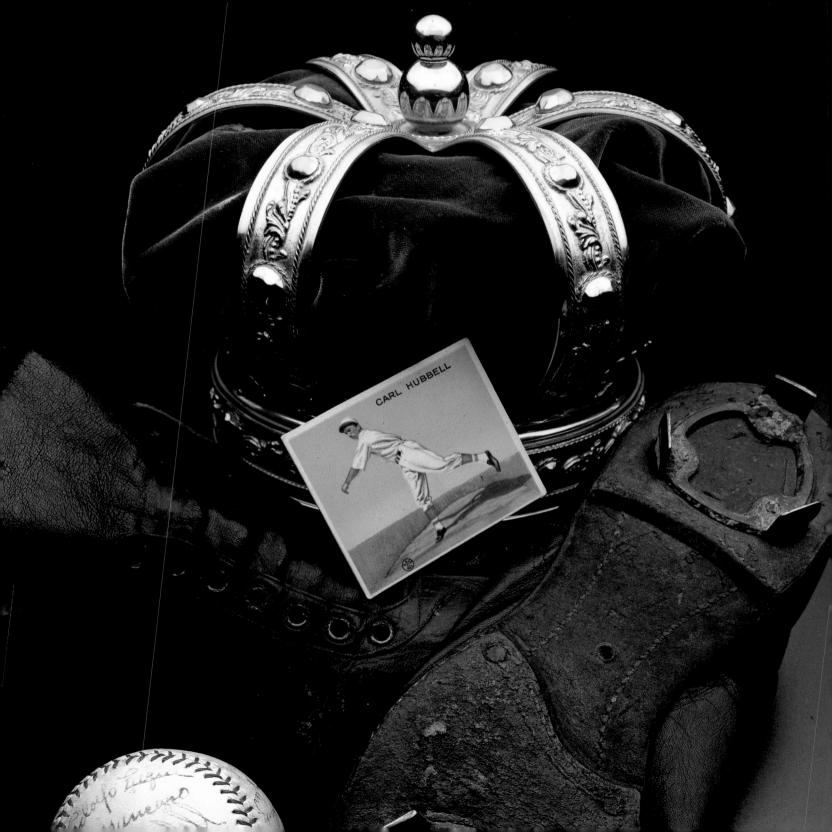

Cy Young Award

The major leagues'
most valuable pitcher
award is named in
honor of Cy Young,
who died in 1955.
From 1890 to 1911,
Young played mostly
with the Boston Red
Sox and Cleveland
Indians, during which
time he tallied 511
wins and 76 shutouts.
Some of his pitching
records have stood
for over a century.

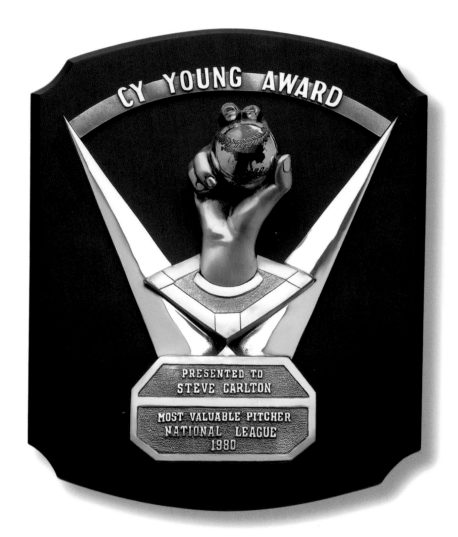

CY YOUNG AWARD

PRESENTED TO
STEVE CARLTON

MOST VALUABLE PITCHER
NATIONAL LEAGUE
1980

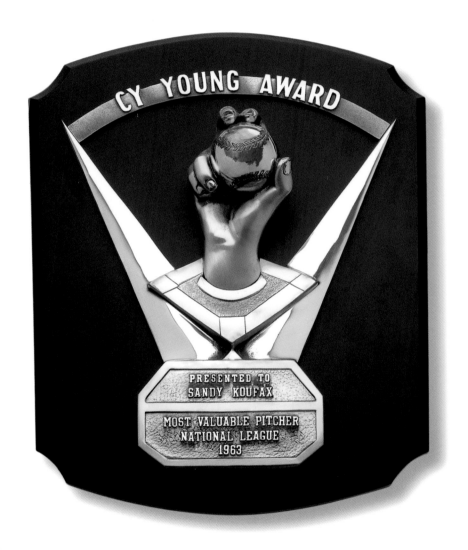

CY YOUNG AWARD

PRESENTED TO
SANDY KOUFAX

MOST VALUABLE PITCHER
NATIONAL LEAGUE
1963

ICON NO. 91

Award Recipients

From 1956 to 1966 only one pitcher was chosen between the American and National Leagues for the Cy Young Award, but in 1967 the rules were changed to name the best pitcher from each league. Shown here are the trophies for Philadelphia Phillies pitcher Steve Carlton, who got the honor four times, and Los Angeles Dodgers pitcher Sandy Koufax, a three-time award winner.

Cracker Jack Card

In 1914, Cracker Jack issued a series of cards featuring 144 star players of the American, National, and Federal Leagues. Walter Perry Johnson, who pitched for the Washington Senators in the American League, was card number 57.

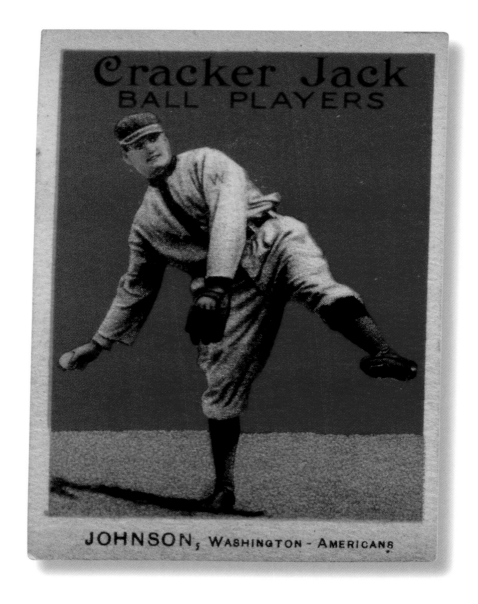

T206 Cards

Among collectors, these cards are known as part of the T206 series, issued by the American Tobacco Company between 1909 and 1911. Cards from this 500+ subject series were placed in packages of Sovereign, Sweet Caporal and Piedmont cigarettes. The top two cards here are of Walter Johnson and Cy Young, and the bottom two are of Christy Mathewson.

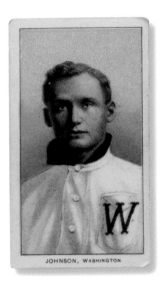

JOHNSON, WASHINGTON

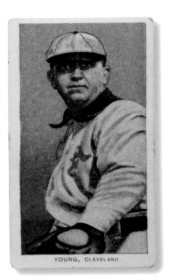

YOUNG, CLEVELAND

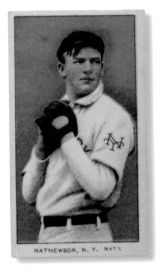

MATHEWSON, N. Y. NAT'L

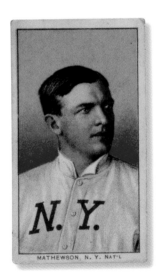

MATHEWSON, N. Y. NAT'L

ICON NO. 94

Screwball Pitcher
Souvenir Pin

Circa 1940, ballparks
and souvenir outlets
sold 1.75 inch black-
and-white celluloid pins
featuring photos of top
players. The likeness
of Carl Hubbell, who
was famous for his
left-handed screwball
pitch, is one of the
most desirable pins
among collectors.

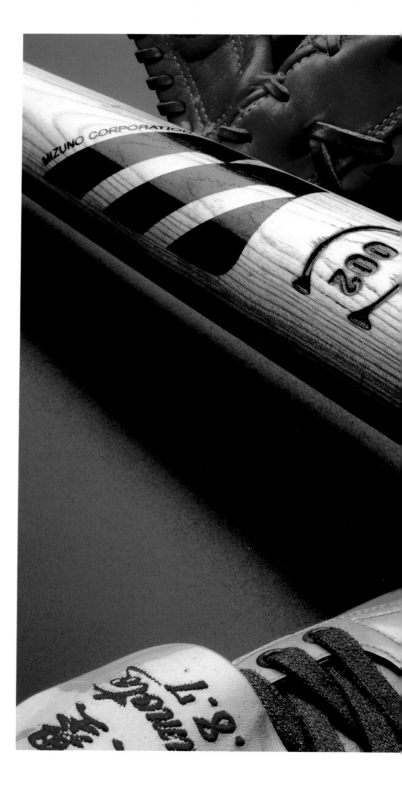

ICON NO. 95

Fukumoto's Gear

Baseball is a sport as
much beloved in
Japan as in the U.S.
Hankyu Braves'
center fielder Yutaka
Fukumoto, inducted
into Japan's Baseball
Hall of Fame in 2002,
set the world record for
career steals in 1983,
the same year he made
his 2,000th career
hit. He retired in 1988
with 2,543 hits and
1,065 stolen bases.

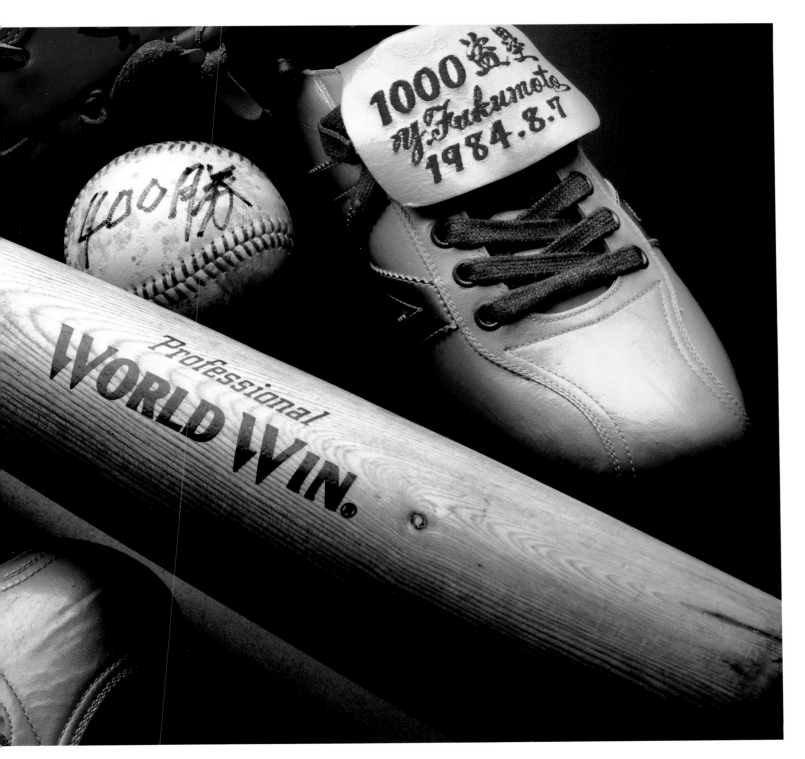

Rain Check

"Rain check" is a term that originated with baseball as early as the 1880s. Frequent summer downpours caused many a game to be rained out, so ticket holders were given rain checks that they could redeem at another game.

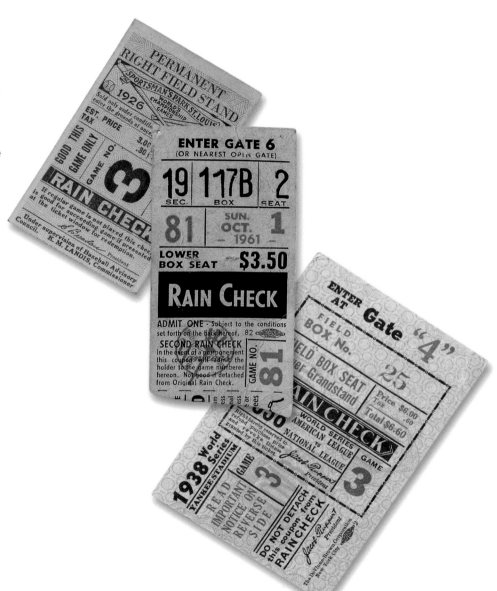

Babe Ruth's Gear

The "Sultan of Swat," Babe Ruth, remains the sole player in major league baseball history to win batting, home run, RBI, slugging, and ERA titles. Shown here are the home uniform jersey, bat, and ball used by Ruth when he hit his then-record 60th home run on September 30, 1927.

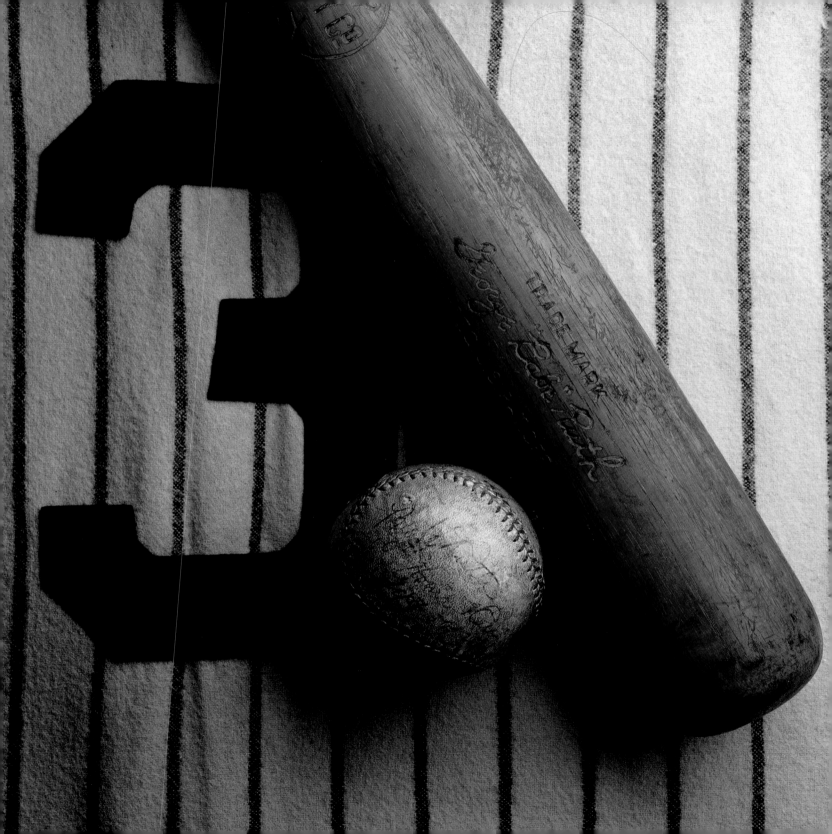

Commemorative Buckle

In 1937, a fan pre-
sented Chicago Cubs
pitcher Clay Bryant
with this homemade
belt buckle to com-
memorate Bryant's
first three years in
the majors. During
his five years with
the Cubs, Bryant
compiled a pitching
record of 32–20.

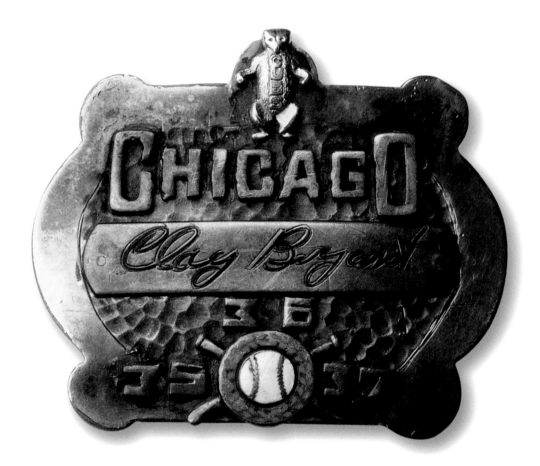

Season Passes

From the late 1910s
to the early 1930s,
baseball officials were
issued sterling silver
season passes to New
York Giants games at
the Polo Grounds. Each
pass was engraved
with the year and worn
on a neck chain.

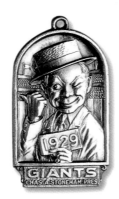

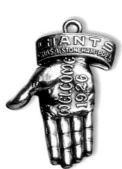

ICON NO. 100

**Baseball
Theme Song**
———————————
In 1908, Jack Norworth
wrote the lyrics to
"Take Me Out to the
Ball Game" on a
scrap of paper while
riding a Manhattan
subway. He handed
it to Albert Von Tilzer
who came up with
the melody. Now one
of the world's most
familiar tunes, the
song is played at many
major league games
during the seventh
inning stretch. Stadium
fans sponaneously
leap to their feet and
merrily sing the lyrics
about buying some
peanuts and Cracker
Jacks and rooting
for the home team at
the old ball game.

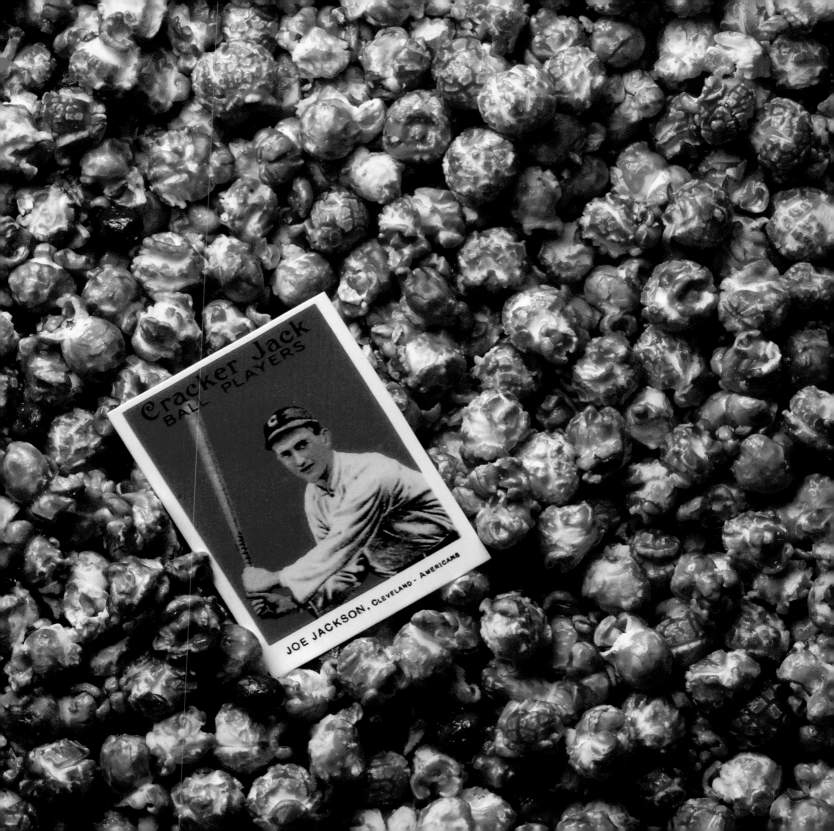

SPECIAL THANKS

We would like to thank Aaron Wehner for helping to instigate this book;
and Brie Mazurek, our editor, for keeping us on track.
Additional thanks to Director of Business Development Scot Mondore, Curator of Collections Peter Clark,
and Librarian Jim Gates and his associates Gabriel Schechter, Bill Francis, and Russell Wolinsky for their research assistance
at the National Baseball Hall of Fame and Museum. A special thanks to Amanda Bollinger and Gabriella Rossi
for their perseverance in designing and producing this book.

CREDITS

Ten Speed Press
PO Box 7123
Berkeley, California 94707
www.tenspeed.com

Distributed in Australia by Simon and Schuster Australia, in Canada
by Ten Speed Press Canada, in New Zealand by Southern Publishers Group,
in South Africa by Real Books, and in the United Kingdom and
Europe by Publishers Group UK.

Cover and text design by Kit Hinrichs/Pentagram
The National Baseball Hall of Fame and Museum™
is a registered trademark of the National Baseball Hall of Fame and Museum.

Library of Congress Cataloging-in-Publication Data
Heffernan, Terry. 100 Baseball Icons : from the National Baseball Hall of Fame and Museum Archive /
photography by Terry Heffernan ; design by Kit Hinrichs ; text by Delphine Hirasuna.
p. cm.
ISBN-13: 978-1-58008-916-6
ISBN-10: 1-58008-916-X
1. Baseball—United States—History. 2. Baseball—United States—History—Pictorial works.
3. National Baseball Hall of Fame and Museum—History. I. Hinrichs, Kit. II. Hirasuna, Delphine, 1946–
III. National Baseball Hall of Fame and Museum. IV. Title. V. Title: One hundred baseball icons.
GV863.A1H44 2008 796.3570973—dc22 2007040195

Printed in Singapore
First printing, 2008
1 2 3 4 5 6 7 8 9 10 — 12 11 10 09 08